FREEPORT
MEMORIAL LIBRARY

Presented by

Scandinavian Society

IN MEMORY OF

Ruth Johnson
2003

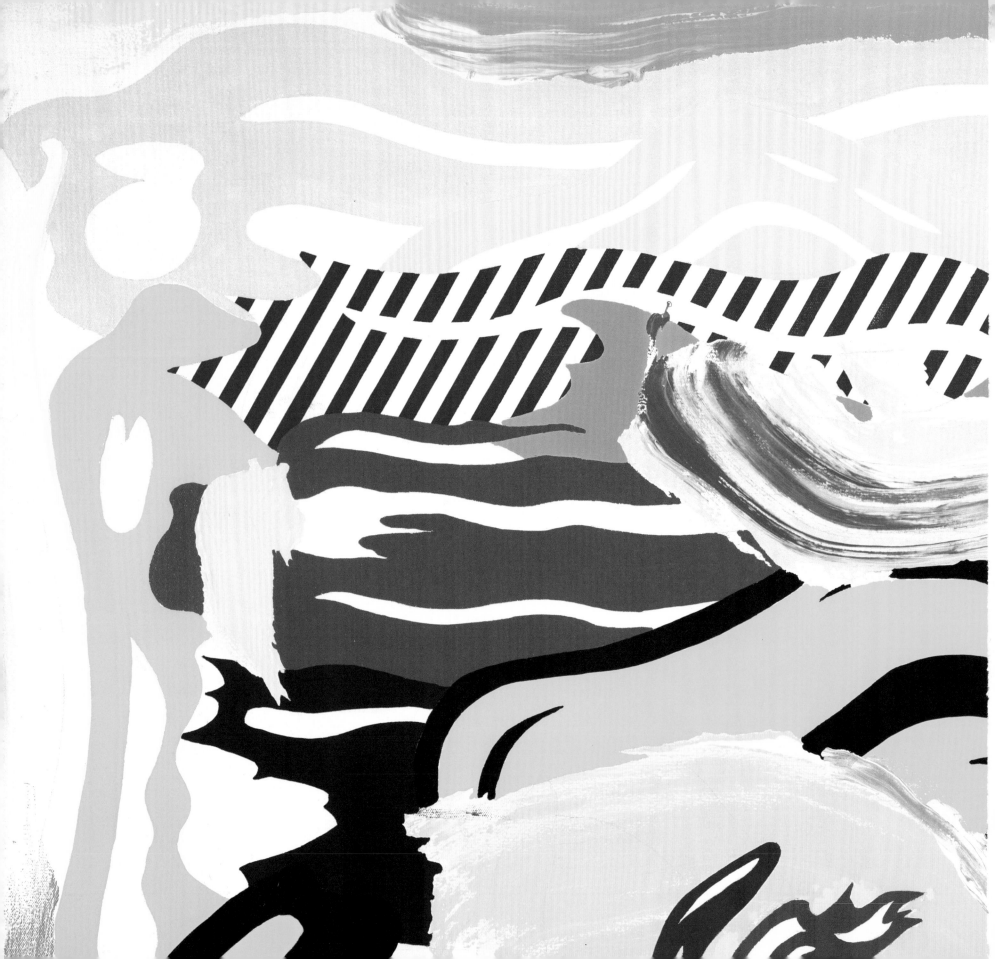

Roy Lichtenstein

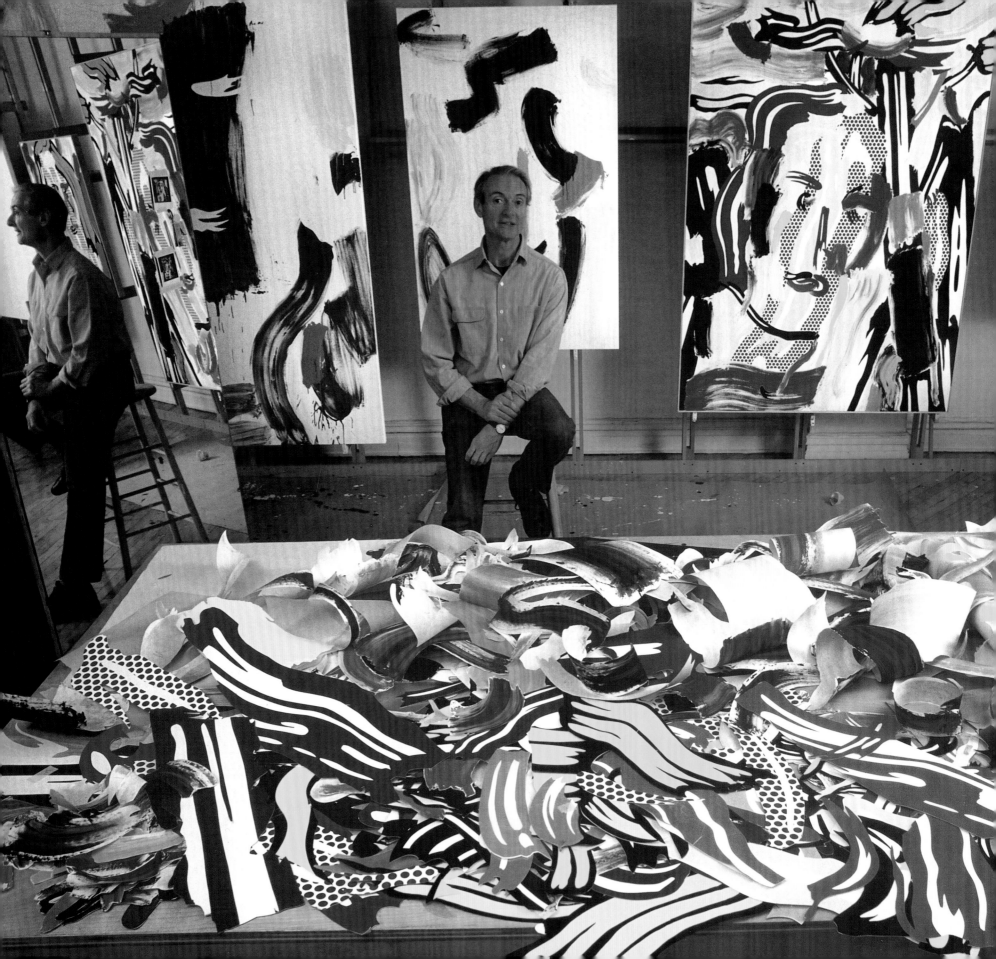

Roy Lichtenstein

Brushstrokes: Four Decades

Essay by Dave Hickey

Mitchell-Innes & Nash New York

Preface

It is with great pleasure that Mitchell-Innes & Nash presents the first major survey of Roy Lichtenstein's work since the artist's death as our inaugural exhibition as representatives of his Estate and the Foundation.

We have chosen to focus on the "brushstroke," a theme central to Roy's work throughout his long career and are presenting paintings, drawings and sculpture (some never before exhibited) which range from his pre-Pop abstractions through the lavish hedonism of the 1980's, to works from his two final series: 'the Chinese landscapes' (in which the brushstroke is ever-present) and the monumental brushstroke sculptures conceived in 1996. Roy employed every medium, technique and scale in the pursuit of his vision: small drawings in pencil and crayon, brushstrokes on acetate, collages, monumental brushstroke sculptures and a rich array of canvases. The exhibition invites the viewer to see the artist above and beyond the stereotypical view of Roy Lichtenstein as a "Pop" artist.

We are enormously grateful to the Estate and the Board of Directors of the Roy Lichtenstein Foundation for making documentation and this rich group of works available for the exhibition. Our particular thanks extend to Dorothy Lichtenstein for her drive and enthusiasm with every stage of this exhibition and catalogue. We also thank Mitchell and David Lichtenstein and Renee Tolcott for their interest and support in our first venture.

Jack Cowart and Cassandra Lozano, the Foundation's Executive Director and Managing Director, respectively, initiated the theme of this exhibition, taking advantage of insights gained during their in-depth cataloguing of Roy's previously undocumented preparatory works, sketchbooks and studio effects. We thank them for their support and for their continuous contributions to this venture as it has grown. We are also grateful to Natasha Sigmund and Sarah Kornbluth of the Foundation and Shelley Lee of the Estate for their generous help with several aspects of the show.

We thank James de Pasquale, Roy's studio assistant, for his first-hand insights into the technical processes of the paintings and sculptures, and for his help with various phases of the exhibition: from preparatory work to installation.

Dave Hickey has contributed immensely with his compelling essay in the catalogue. We are grateful to him for taking time out of his busy summer to produce such a personal and original text which challenges the way we traditionally think about Roy's art.

Roy's spirit lives on through every paint mark, pencil trace, brushstroke in both the paintings and sculpture. By approaching the work with this broad and ambitious theme we hope to be able to cast new light on both the art and the artist's thought process and to bring the vigor and freshness of his work to a new and emerging group of collectors and institutions.

Lucy Mitchell-Innes

September 2001

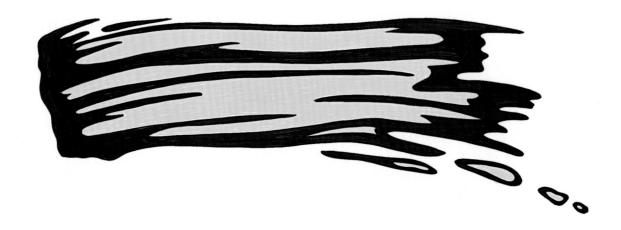

Fig. 1 **Untitled (Spoeri Project)**, 1971, Magic marker, yellow crayon and graphite on paper, 17³/16 x 41¹/2 in. (43.7 x 105.4 cm.)

Brushstrokes

Dave Hickey

I first encountered Roy Lichtenstein's "brushstroke paintings" on a cloudy December afternoon in 1965. By that time, I was already on the team, but I had never once, before that afternoon, thought of it as the winning team. I thought of it as the cool outsider team. That afternoon I realized that I might be a part of something that really could happen. I walked into Leo Castelli's gallery, and found that Lichtenstein's paintings had quite literally cleared the air. I can still remember the emptiness of the rooms and the clean, articulate surfaces of the canvases, their ambiance of eloquence without angst, of modernist difficulty without theatrical struggle. I also remember that the paintings looked extremely new, and I have never stopped liking that. Most of the post-war American paintings that people of my generation grew up around looked old and distressed even when they were brand new, so it was an important part of the Pop project to make objects that looked new and cool.

Roy's paintings did that, but they were not heartless; there was real feeling in them, a kind of intelligent joy shaded by genuine nostalgia for the heyday of painterly abstraction and the happy days of newspaper graphics.

At that time, of course, these sources were still at hand. There were still a lot of abstract expressionists around, in the bars and in the galleries, but they didn't walk the way we did (probably, we speculated, because of the paint on their shoes). Even in their natural habitats, at the Cedar and St. Adrian's, they seemed phase-shifted, newly out of place, like old boxers who had wandered into a taping of American Bandstand. The old-time cartoons were still available, too— strips like *The Little King* and *Jiggs and Maggie*— but the pages upon which we read them seemed to yellow under our eyes. In the florescent glare of the television world that was superceding them, these strips seemed exquisite and antique, like engravings in a Victorian novel. They were still there, however, and still alive until Roy Lichtenstein's magisterial paintings relegated them both, irrevocably, to the past. The sheer sweetness and gallantry of Lichtenstein's homage, which found in these sources no threat or source of anxiety, killed them both with kindness.

Not surprisingly, then, the first thing I became aware of as I looked at the brushstroke paintings was what was gone, what had been killed with kindness. First, I noticed that the Benday dots, recruited in the service of an abstract image, lost the blowsy, strident vulgarity they had retained in Lichtenstein's earlier work. They now declared their historical sources in the pointillism of Seurat and took on the peculiar quiet that suffuses *La Grande Jatte*. The brushstrokes themselves, swimming in this silence, lost their noisiness too. Bereft of their claim on us, they became elegant, well mannered and deeply amusing. Liberated,

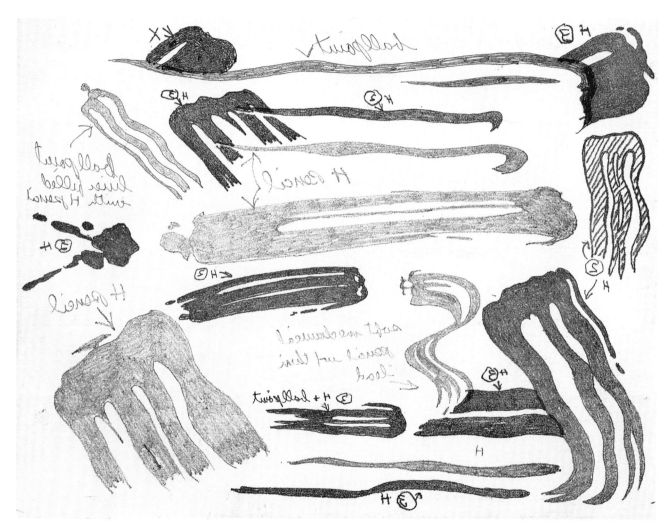

Fig. 2 **Test Print of Brushstrokes**, Circa 1979-1980, Soft-ground etching, aquatint and engraving on paper, Image: 7 x 9³/8 in. (17.8 x 23.8 cm.) Sheet: 11¹/8 x 14³/4 in. (28.3 x 37.5 cm.). For the **American Indian Theme** series (cf. Corlett nos. 166-171), with the artist's notations: H3; ballpoint; H2; H Pencil; ballpoint lines filled with H pencil; soft mechanical pencil with thin lead; H2 + ballpoint

somehow, by the works' cool self-sufficiency, I realized for the first time, how profoundly my role as a beholder of New York School paintings had been infected by the cultural assumption that I was there, at least in part, to serve as a care-giver, as a public sympathizer with the heroic artist's angst and struggle. Previous pop exhibitions, like Oldenburg's Store and Andy's Brillo Boxes at Stable, had dispelled this sickroom miasma by exciting my adolescent glee, but standing before Lichtenstein's brushstrokes, I felt as I rarely had in a contemporary art gallery, like a free adult, neither parent nor child. I felt, as well, that American contemporary art might now become something adult, something grand without grandiosity, serious without solemnity.

Like Andy Warhol's soup-cans, Lichtenstein's brushstrokes were, clearly and at first glance, generational icons. They proposed a critique of the immediate past, clearly intending to supercede it without destroying it— to propose something new that would renew the past, as well. Andy's soup-can paintings canned the "soup" of abstract expressionism and identified its purported authenticity with trademark "taste." By straining the signature gesture of New York School painting through a screen of Benday dots, Lichtenstein's paintings proposed the primacy of placement and design over action and urgency— a rather daring proposal, I thought, since it only made sense if Lichtenstein's paintings were, in fact, achieved and persuasive objects. Fortunately, they were. They delivered the effect of high-style American painting coolly through efficacious means, and, in the process, delivered American art from the tyranny of anxious execution and difficult means— from the assumption of psychological dysfunction and tragic destiny that had pervaded post-war practice.

Previous icons of Pop had never quite managed to make this break or to debunk this mythology. Because of their lumpen subject matter and ludic ambiance, works of pop art were routinely presumed to be playing Polonius to abstract expressionism's Hamlet— to be serving as a comedic complement to abstract expressionism's heroic tragedy. In order to maintain this fantasy, the icons of Pop had to be misconstrued as de facto critiques of the "commodity culture" that the commodities of New York School painting strove so ardently to transcend. So they were misconstrued in this way and still are today— but the painterly brushstroke, even in a Pop painting, is no mundane object. Nor, except for the first brushstroke, did Lichtenstein appropriate his brushstroke images. He designed them himself, which is the only proper way to simulate the singular icon of rhetorical eloquence in Western painting. With this fiat— this lateral move into conceptual iconography— Lichtenstein blatantly raised the ante.

Far from offering putative comic relief from painterly heroism, Lichtenstein brushstrokes clearly aspired to replace them, and, in the friendliest manner imaginable, they did just that, not by offering up a new historical style to supplant painterly abstraction, but by offering an alternative model of artistic practice that repositioned abstract painting in a broad field of equally weighted endeavors. In the simple terms, Lichtenstein sought to retain the rhetoric of doubt, difficulty and latent abstraction that invigorates modernist practice while dispensing with its directional historical thrust. To do this, he shaped his practice on a premodern model, which prescribes nothing more ideological than painting various subjects in various ways at various times, deciding at every crossroad which path to take and not before. The chronology of Lichtenstein's endeavors preceding the brushstroke paintings

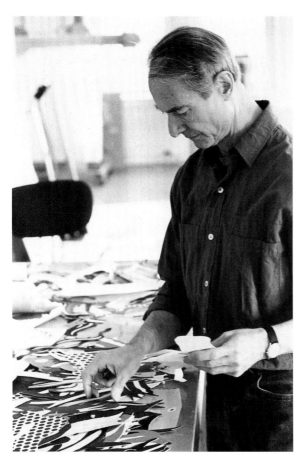

Fig. 3 Roy Lichtenstein, 1985, 29th Street studio

reveals the armature of this model. He begins with diaristic cartoon images that are allegorical narratives of his budding career and with advertising images of commercial objects— at once the *nature morte* and devotional painting of commercial culture. He then embarks upon his War Comics series, effectively re-inventing history painting. From there, he moves to the Romance Comics, which self consciously reconstitute pre-Raphaelite genre painting in cartoon drag; from there he moves to landscapes and then on to the brushstrokes.

The project couldn't be simpler. Lichtenstein reinvents the traditional pictorial genres of painterly practice in the west, (landscape, still-life, history painting, etc); he then redefines abstract painting as one of these genres. The historical appropriateness of Lichtenstein's project is reinforced, I think, by the fact that Andy Warhol proceeded similarly at the same time, while in Germany, again the same time, Gerhard Richter was independently ringing the same changes in a different key. In Richter, the "blur" rather than the Benday is the signifier of modern doubt. In Warhol it is the silkscreen blot, but the practical ends of all three artists are amazingly similar: the broadening of painterly practice and the reconstitution of abstract painting as a pictorial genre in its own right. What distinguishes Lichtenstein's project is his profoundly American insight into the machinery of modern culture, his understanding that the perpetuation mass culture

had created a sort of "image wheel" upon whose turning spokes defunct beaux arts practices, rather than disappearing from sight, cycled down into the compost of popular culture from which they might be retrieved as needed.

This, of course, explains what we already know: that Roy Lichtenstein's penchant for vulgar technique and retro-imagery derived directly from his knowledgeable affection for the high art of the past (for which popular art is little more than a tumultuous warehouse, where Seurat survives in Benday dots and Rossetti lingers in Romance comics). In fact and more generally, art historical self-consciousness has turned out to be the great, unacknowledged virtue of *all* those Pop artists, who, in the moment of their apotheosis, were routinely derided as philistines who lacked it. What these artists lacked, it now turns out, was simply what they hated: the *utopian* historical consciousness that seeks to render the past obsolete. This was never the project, and especially not Lichtenstein's. They all wanted to keep everything. Thus, far from abolishing the painterly brushstroke, Lichtenstein's brushstroke paintings simply retire it to the warehouse of popular culture— where, in fact, he found it (in a cartoon narrative about a painter) and from which he himself would retrieve it when he needed it.

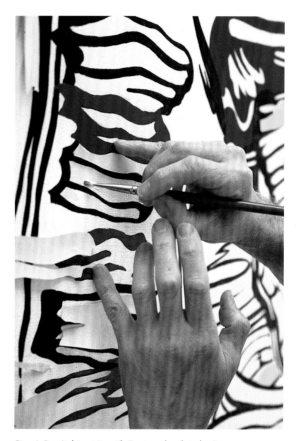

Fig. 4 Roy Lichtenstein with "cartoon brushstrokes" in Southampton, 1981

* * *

In this sense, then, Lichtenstein's first brushstroke paintings are ardently triumphalist works— Wildean comedy of the highest order. They complete the project of his early career and, along with contemporary work by Ellsworth Kelly, Andy Warhol, Dan Flavin and Don Judd, they mark a virtually timeless, Augustan moment in the history of American art— a moment that was not timeless, of course. It would pass into the ambient gloom of Altamont, Nixon, Vietnam and Watergate, but however foolishly confident and carelessly arrogant the insouciant optimism of that moment might seem in retrospect, I can assure you that, in that moment, Lichtenstein's brushstroke paintings were *exactly* what I wanted to see, and, to give credit where it is due, they were exactly what I had been *prepared* to see by Gordon Mills, who was my graduate theory professor at the University of Texas.

At that time, back in Austin, one of my tasks as Gordon's graduate assistant was grading his mid-term aesthetics exams, upon which this question always appeared toward the end: "How would Raphael have painted Titian's *The Flaying of Marsyas?*" Roy Lichtenstein would have gotten an "A" on this question but the undergraduate students whose papers I was grading nearly always got it wrong. They presumed that they were being asked how Raphael might have treated the "story" of Marsyas, a Phrygian satyr who was flayed alive after losing a musical contest with Apollo. The better students caught the inferred analogy between the god Apollo and the Apollonian Raphael, between the satyr Marsyas and the Dionysian Titian. They inferred from this that Raphael might have treated the subject differently. The best students noted that flaying must have seemed a particularly heinous punishment for Titian, whose paintings, like satyrs, had rough skins.

Very few, however, caught the actual inference of Professor Mills' question, which asked specifically how Raphael would have painted Titian's painting, not how he would have treated Titian's subject. What Gordon wanted was some speculation on how Raphael might have accommodated the haptic eloquence of Titian's Venetian rhetoric to his own cerebral style of linear Tuscan conceptualism. To do so, Raphael would have had to render Titian's large marks in his own small ones, to lengthen Titian's short gestures into his own long ones and paint a graphic representation of Titian's object. In short, he would have had to flay Titian's painting as Apollo flayed Marsyas— as Roy Lichtenstein flayed the brushstroke.

The question in actual practice, as opposed to a hypothetical question on a quiz, of course, is *why flay Titian at all?* Why flay de Kooning? Why flay the brushstroke? The answer in Lichtenstein's case, I think, and in Warhol's as well, has little to do with the physical eloquence of the gesture or its artistic viability and everything to do with the fact that the brushstroke, at that historical moment, came to *mean* something that it had not before and has not since. To be blunt, the brushstroke, in post-war America became an animist fetish for "spontaneity" and "authenticity" construed as the cardinal virtues of *resistance*. Historically speaking, northern European cultures with traditions of repression and regimentation have fetishized these Adorno-esque virtues for several centuries. So it is not surprising, perhaps, that a country like the United States, emerging from a period of massive militarization would fetishize these same virtues and, in its post-war art, invest an aristocratic gesture like the brushstroke with their meanings.

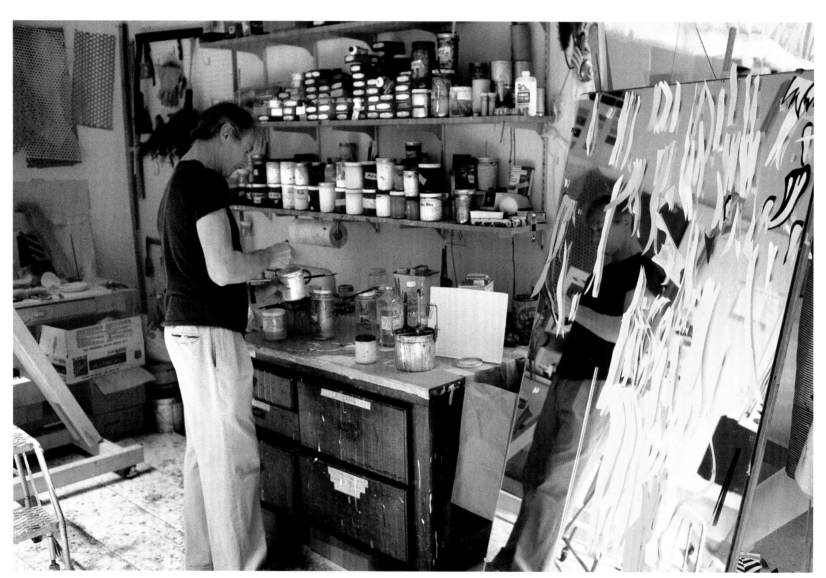

Fig. 5 Roy Lichtenstein with "cartoon brushstrokes" in Southampton, 1981

Unfortunately, the institutions and traditions that guarantee repression and regimentation have never been firmly enough in place in the United States to guarantee their perpetuation, and the fate of the brushstroke as a fetish of dialectical authenticity and counter-cultural spontaneity pretty much requires the sustained presence of regimentation and repression. Thus, the rapid relaxation of social control in post-war America rather quickly rendered the ideology of the brushstroke not much obsolete as redundant— as the entire population happily embraced spontaneity and authenticity as its raison d'être. As a consequence of this, the frantic eloquence of Pollock's gestures or de Kooning's may, with some historical justification, be read as spontaneous, emblematic expressions of human freedom in the face of cultural repression. Only a few years later, however, a permissive cultural atmosphere would rob such gestures of their social validity and degrade the artist's perception of his own repression from a social reality to a personal, psychological malady.

The problem for artists of this period, then, was how to keep the accomplished brushstroke, which is hard not to like, and which, in the history of art, signifies little more than bravura accomplishment, while dispensing with the vulgar pretense of what it had come to mean. Lichtenstein's first solution to this problem, in his paintings of the late-fifties, was to invest his brushstrokes with visible elements of design and intention. By loading wide brushes with contrasting colors in sequence, Lichtenstein was able to paint stripes that patterned the brushstroke as it was painted, investing the gesture with an aura of prior intention. Now, artists have loaded their brushes with parallel colors throughout history, of course, and John Singer Sargent was famous for it, but Lichtenstein's clear intention, unlike

Sargent's, was to achieve a *graphic* rather than a verisimilar effect. Moreover, given the nature of Lichtenstein's education and his training as a printmaker, it is much more likely that he derived this method of making painterly stripes from split-fountain printing than from the niceties of salon portraiture. If this is so, it marks the beginning of his double-edged romance with graphic printing techniques and incarnate painting.

From that point on in his career, the tension between the vertical address of printing and the horizontal traverse of the painted gesture is never truly absent from Lichtenstein's work. Since it was never truly absent from Warhol's work either, their differing accommodations to the demands of simultaneously printing and painting offers us a way of looking at Lichtenstein's later work that defines its eccentricity. At the most general level, of course, both Warhol and Lichtenstein set printing and painting at odds with one another; they both conflate the tradition of decorative repose with the tradition of modernist difficulty; they both traduce the Venetian tradition of embodied color with the Tuscan tradition of conceptual linearity. The difference between them is this: Lichtenstein was always modernist and Warhol never was. Lichtenstein worshiped difficulty. Warhol worshiped facility. Lichtenstein could take a perfectly accomplished comic book panel and, in his rendering, invest it with tension and anxiety. Warhol would take the clumsiest photograph or commercial image and, with a few effortless gestures, transform it into something breathlessly elegant.

Lichtenstein would routinely force the secondary color language of commercial design back to harsh primaries; Warhol would nuance it off it into limpid tertiaries. Warhol would transform de Kooning's *Marilyn Monroe* into a Byzantine icon. Lichtenstein would trans-

form de Kooning's *Woman II* into an unstable array of graphic brushmarks more difficult and anxious than de Kooning ever was. Warhol made the banal beautiful; Lichtenstein made the decorative difficult. Thus, as Warhol's career progressed, his work became progressively more gorgeous, while Lichtenstein's became progressively more difficult, and if difficulty required hiding the image in the marks that made it, this would be done. If these marks, graphically rendered, required the dissonant reintroduction of real marks, that was done as well.

And there is nothing particularly surprising about this, of course, except for the fact that we subliminally expect artists to mellow in their maturity— except for the fact that our acute historical consciousness has left us unprepared for the anxiety of modernist doubt in post-modern drag— except for the fact that we are unprepared to actually *see* those graphic signifiers that we are used to *seeing through* as we read them. Except for a lot of things, in fact, and the consequence of all these exceptions, is that Roy Lichtenstein's career would make more common sense to us if we read it backwards— but, then again, so would Titian's. They both got younger and more dangerous every day they lived and we are not used to that, nor can we easily get used to the things they made as they became older and braver. Fortunately, those things that we cannot get used to remain more visible and vital than the things we do.

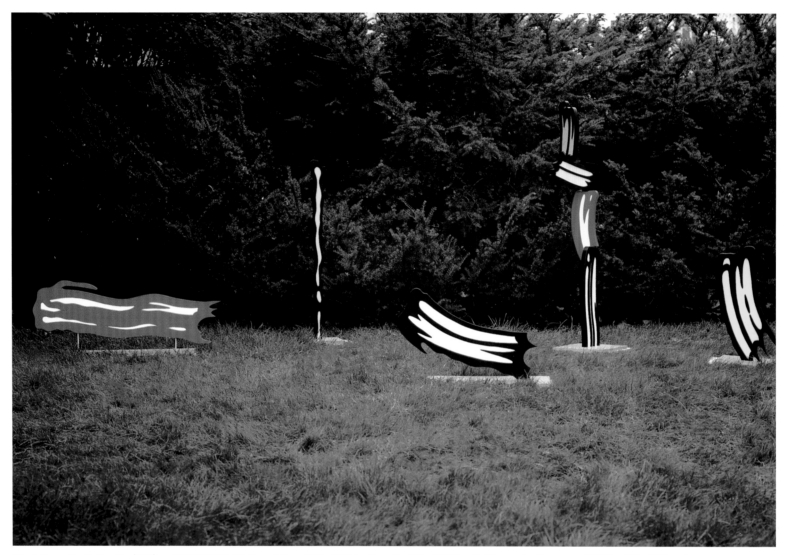

Fig. 6 Maquettes for **Five Brushstrokes**, 1983-1984, Painted wood, From left to right: (red) Length: 42 in. (106.5 cm.); (black and yellow column) Height: 40 in. (102 cm.); (black and white) Length: 30 in. (76 cm.); (brushstrokes) Height: 55¹/₄ in. (140.5 cm.); (black and yellow) Height: 24³/₄ in. (63 cm.)

Plates

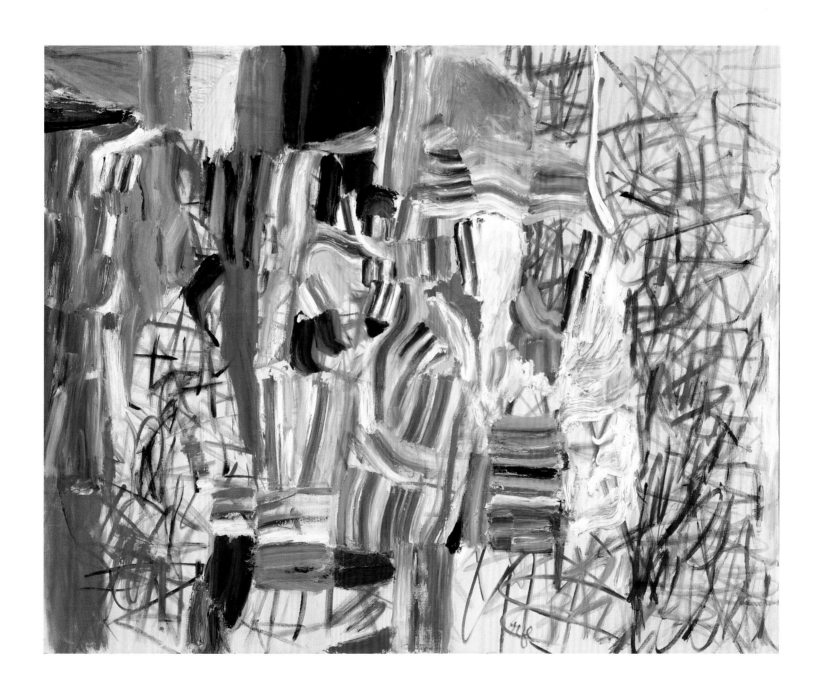

1

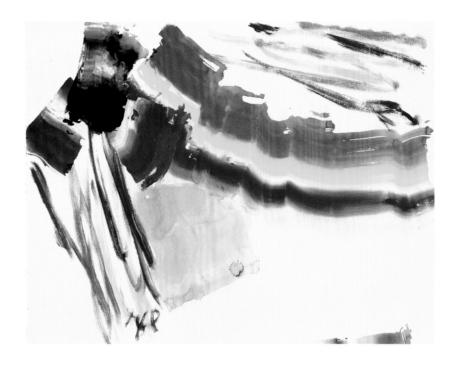

2

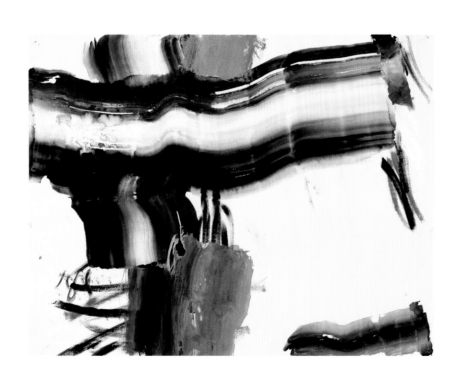

3

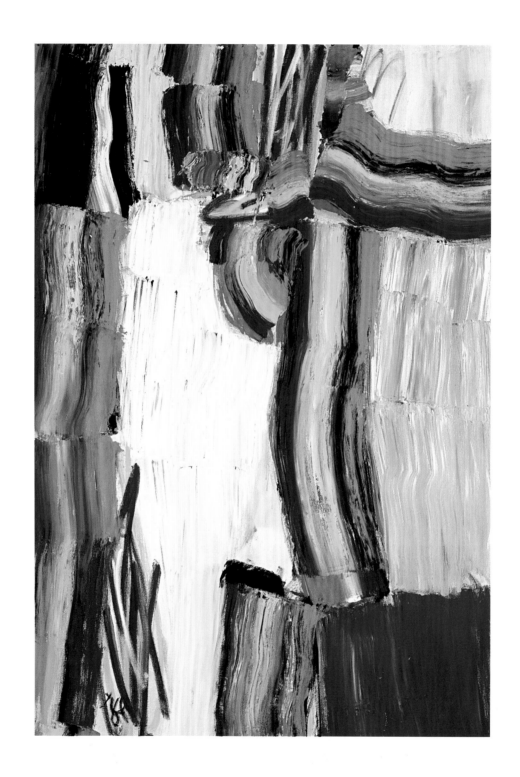

PRINT ALL COLORS WITHOUT
VALUE OR INTENSITY VARIATION BLACK

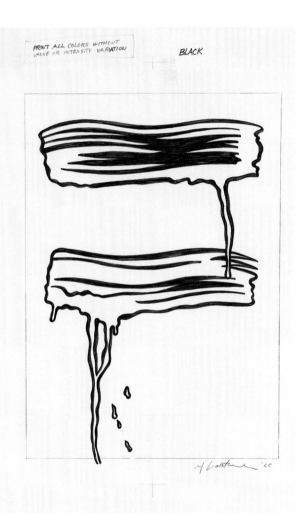

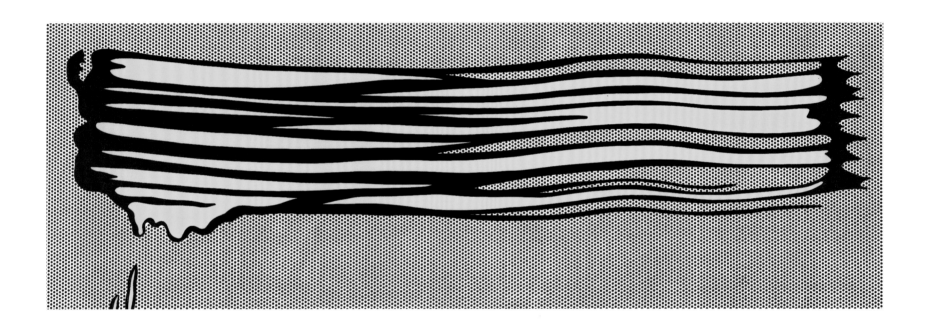

6

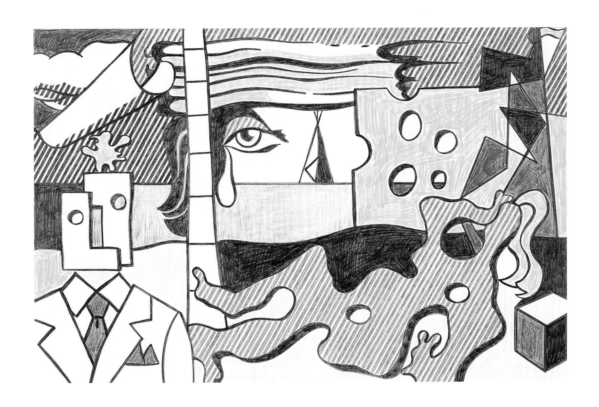

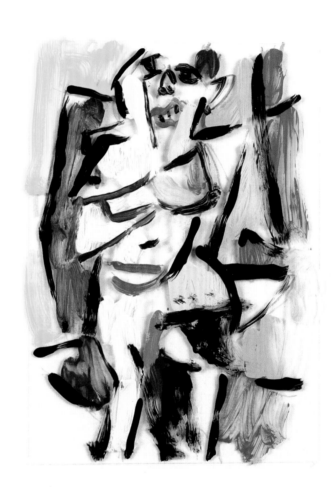

8

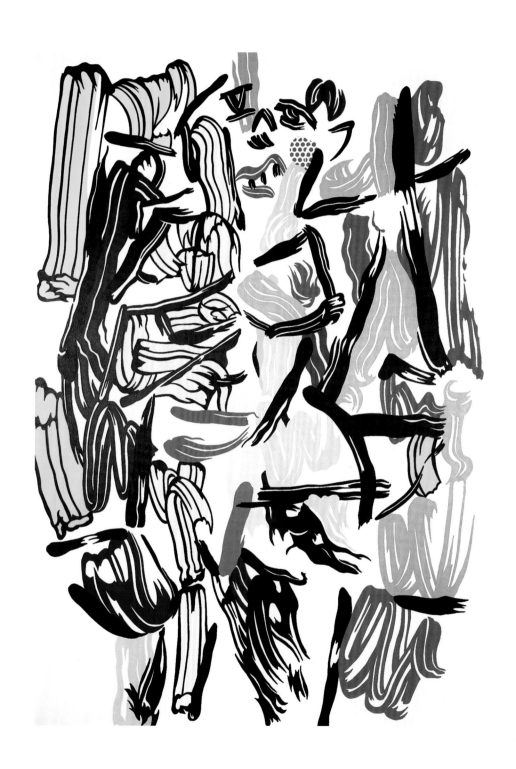

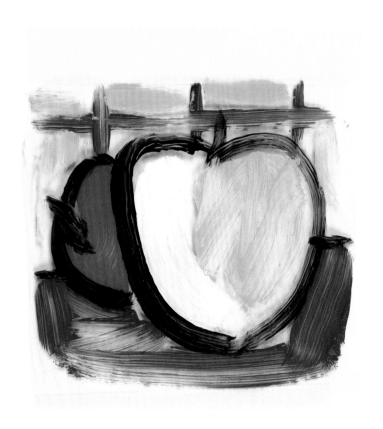

10

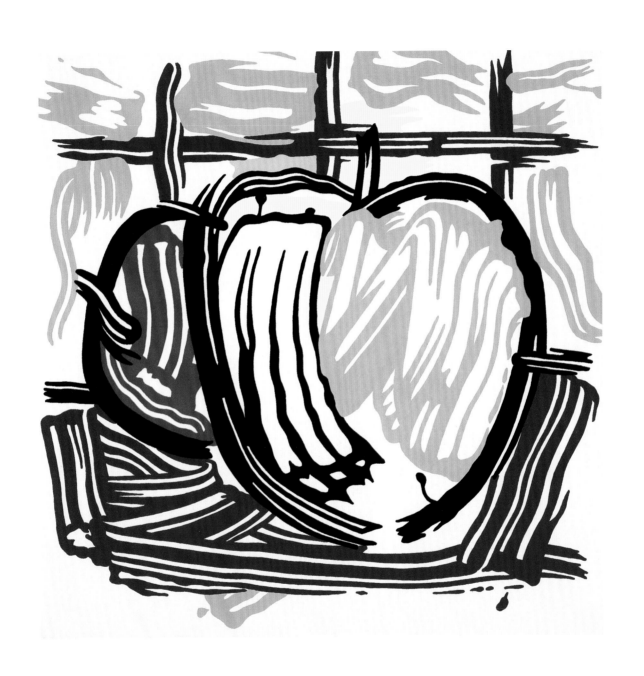

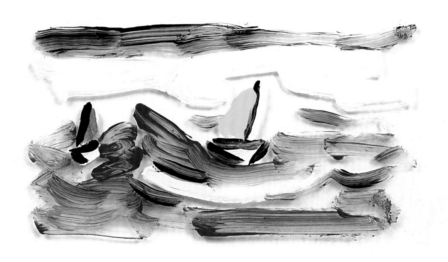

12

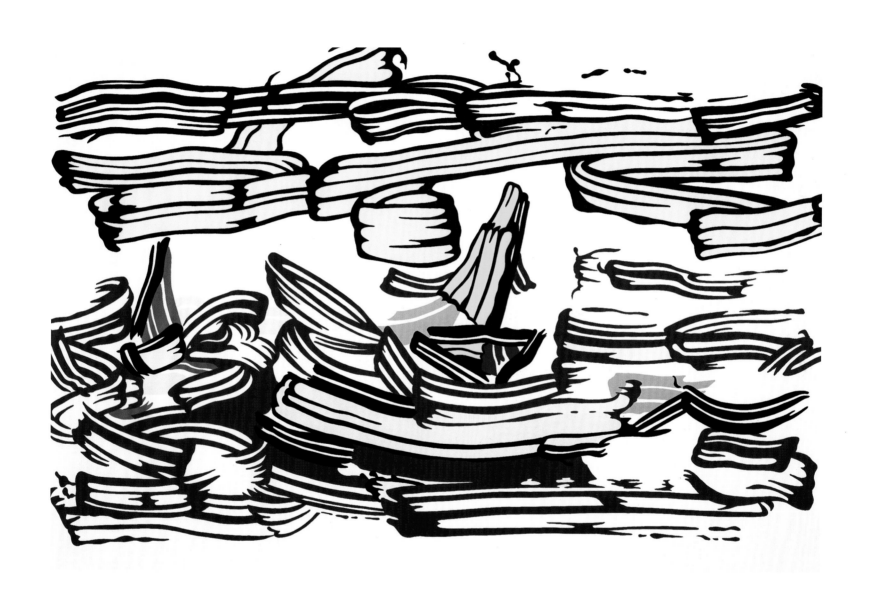

13

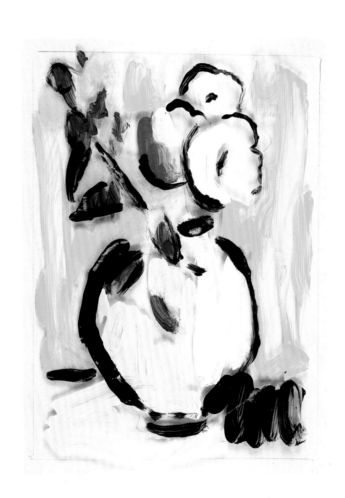

14

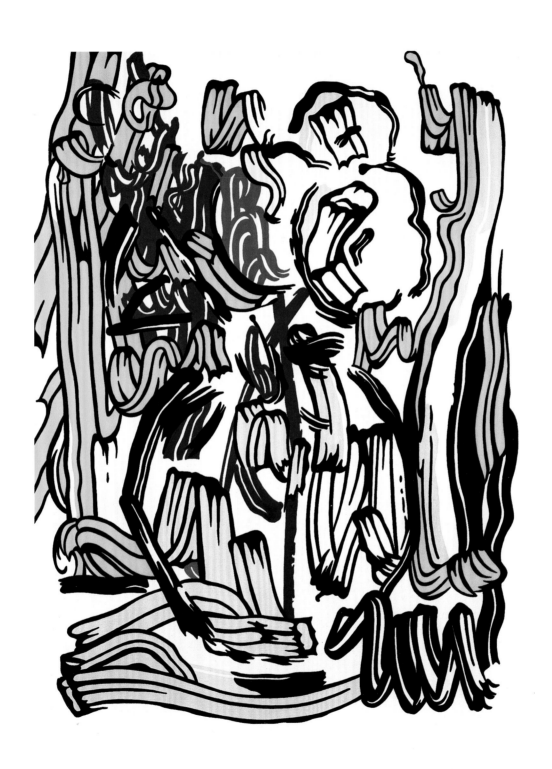

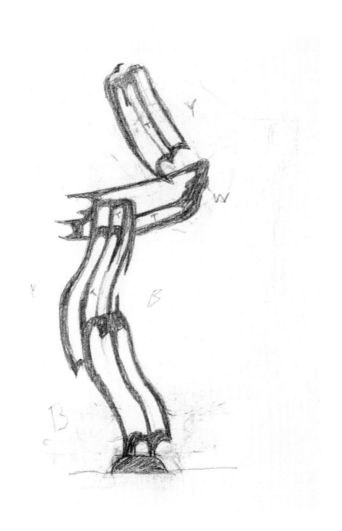

16

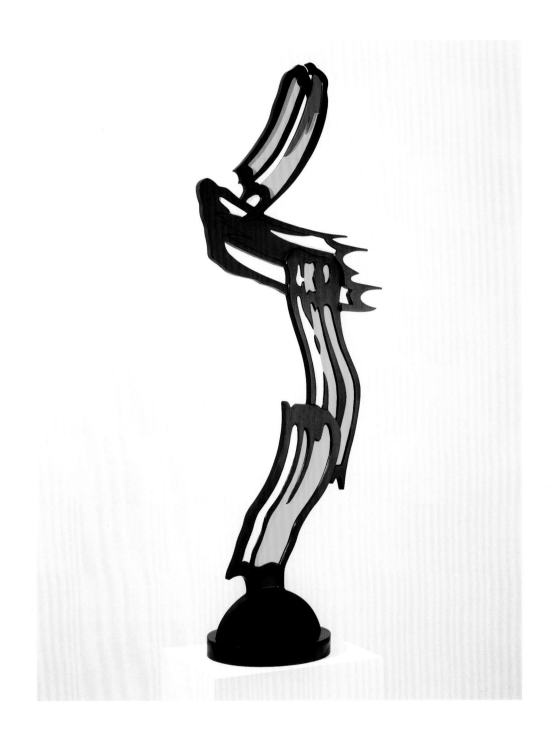

17

36X24

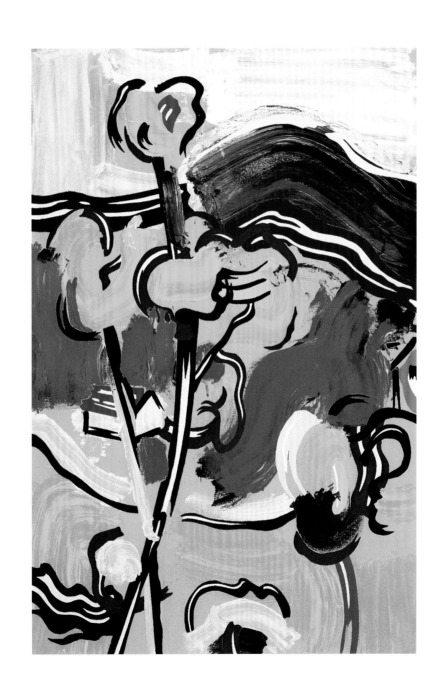

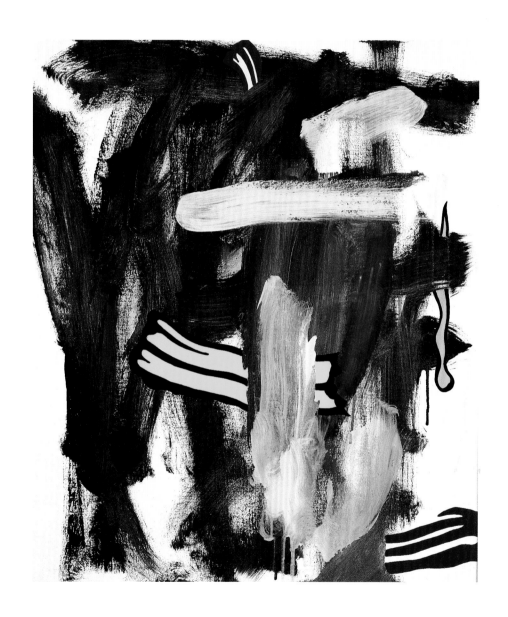

20

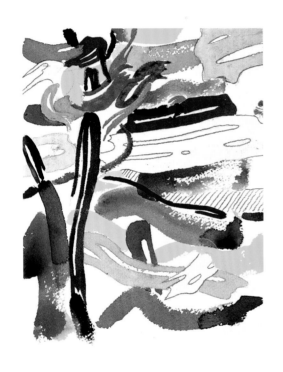

21

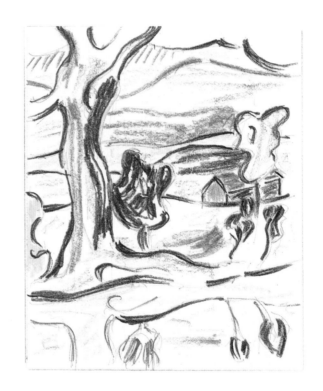

22

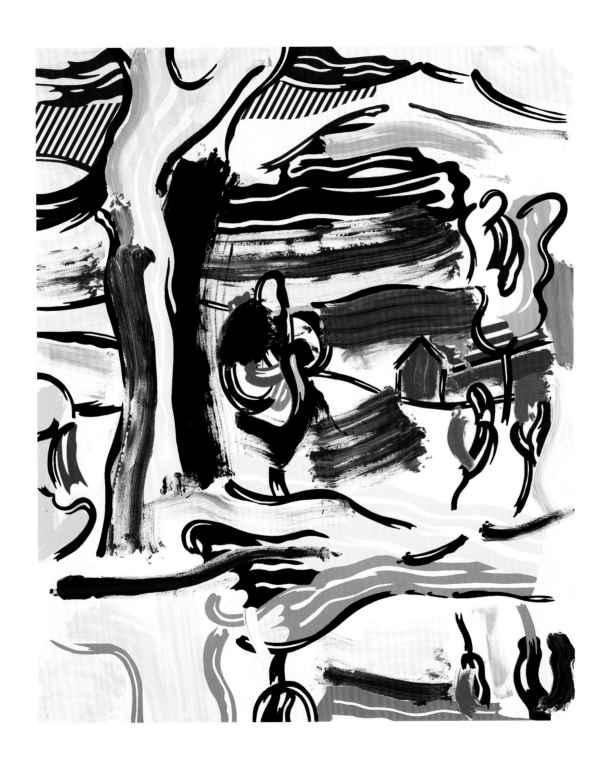

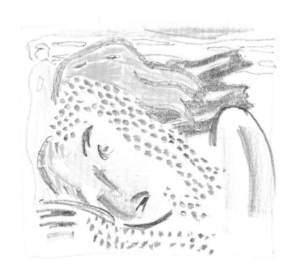

24

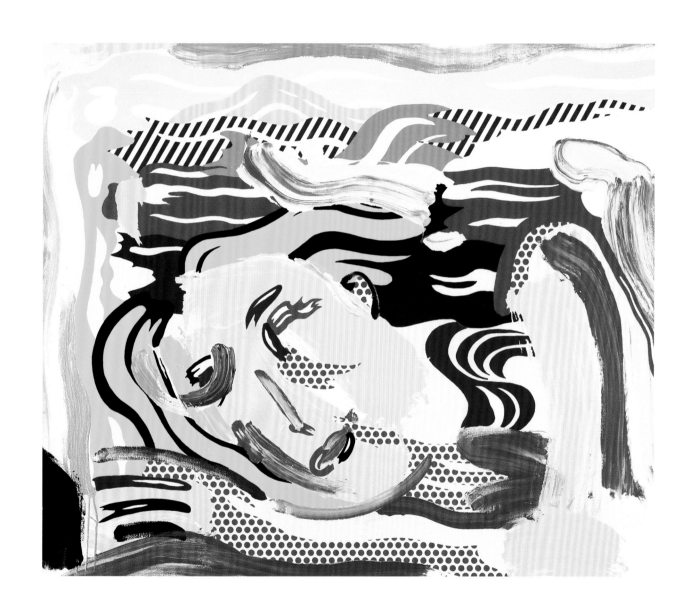

25

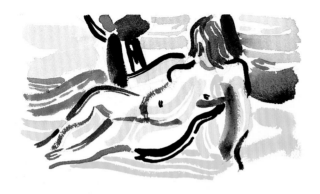

26

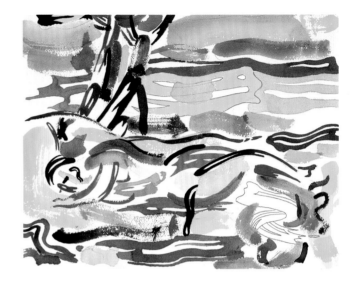

27

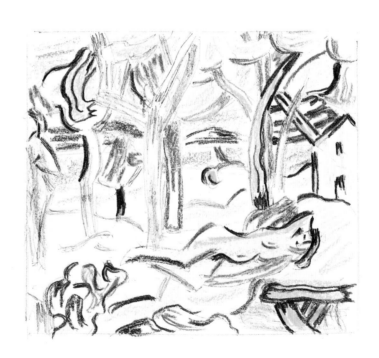

28

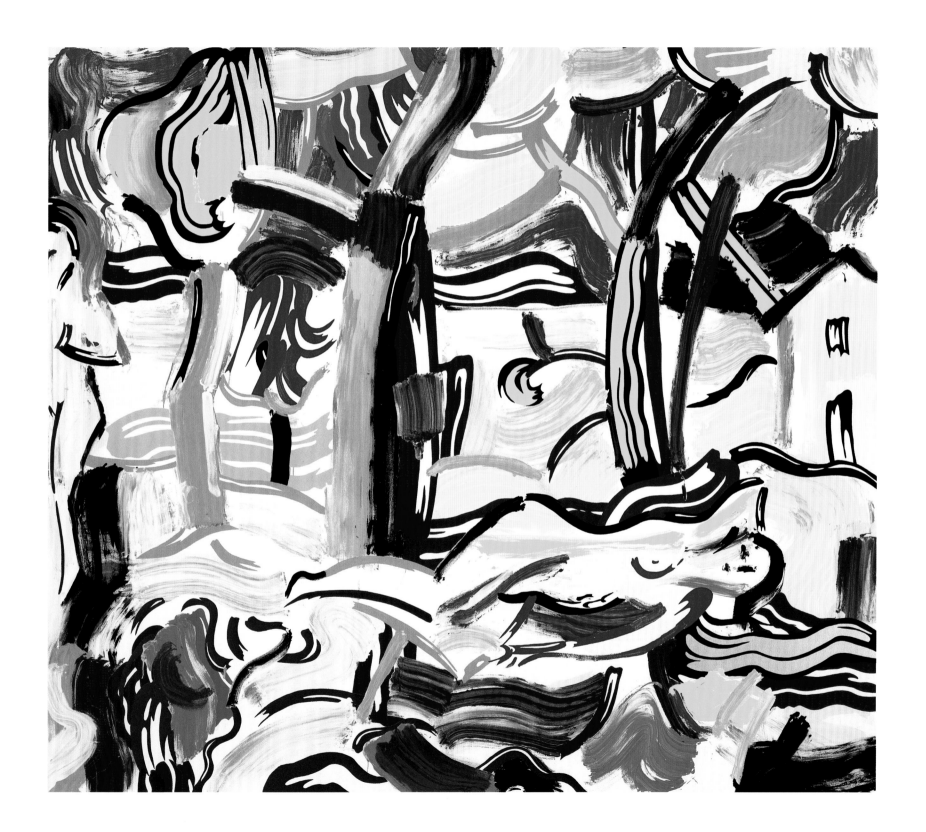

30

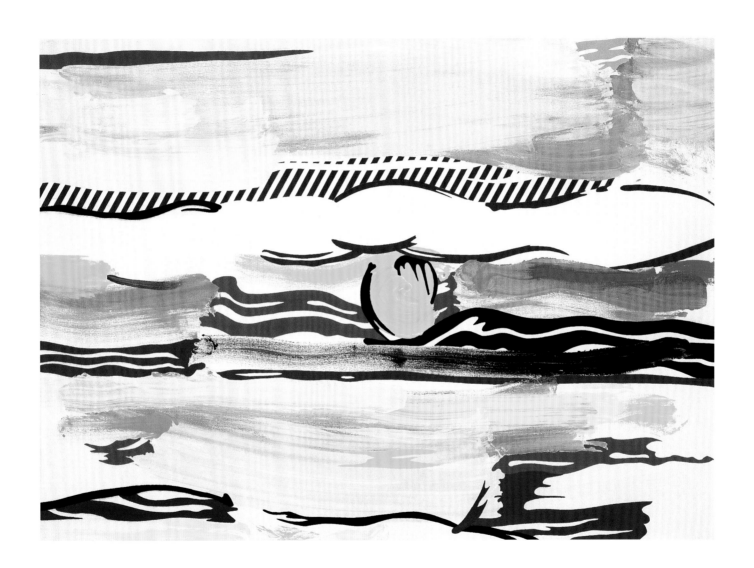

31

32

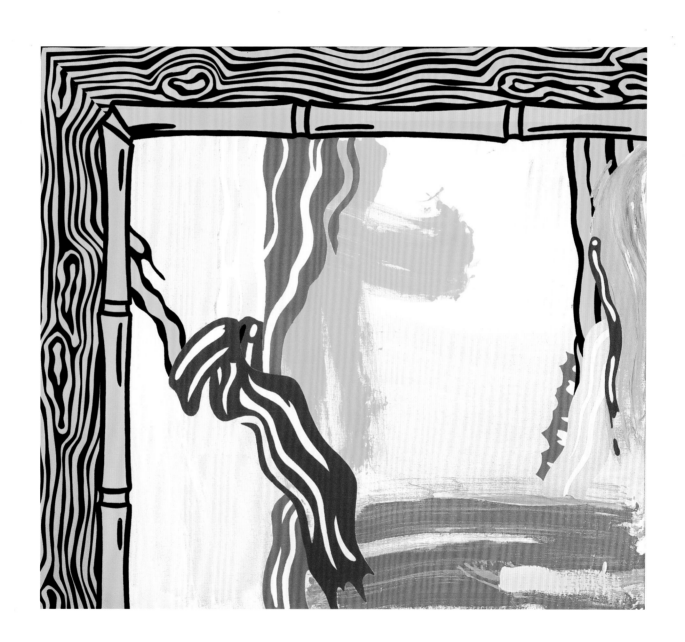

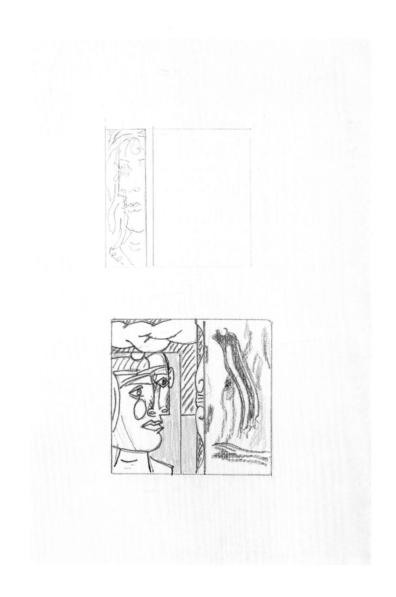

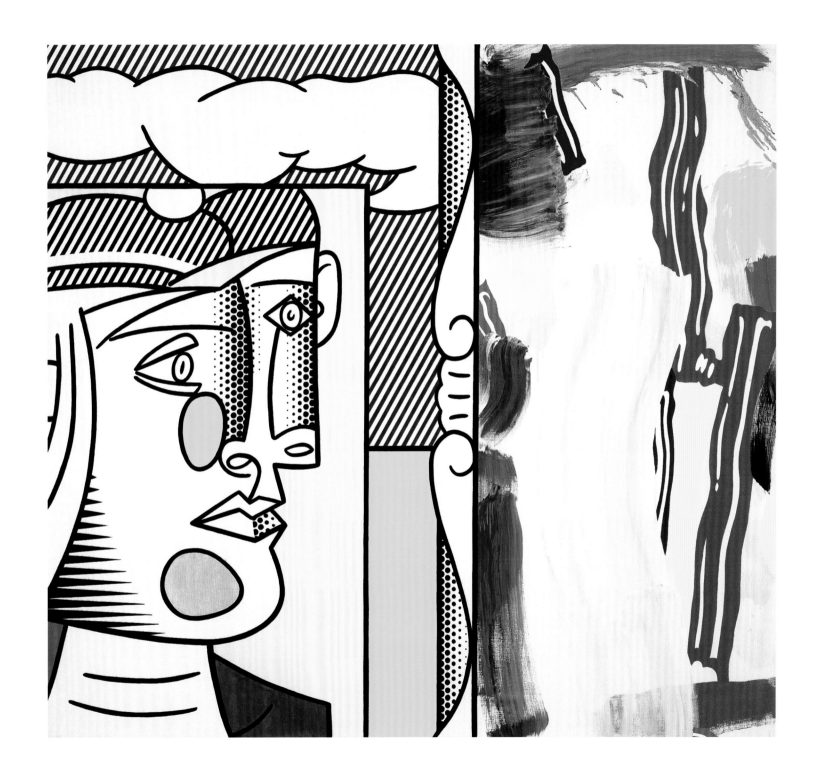

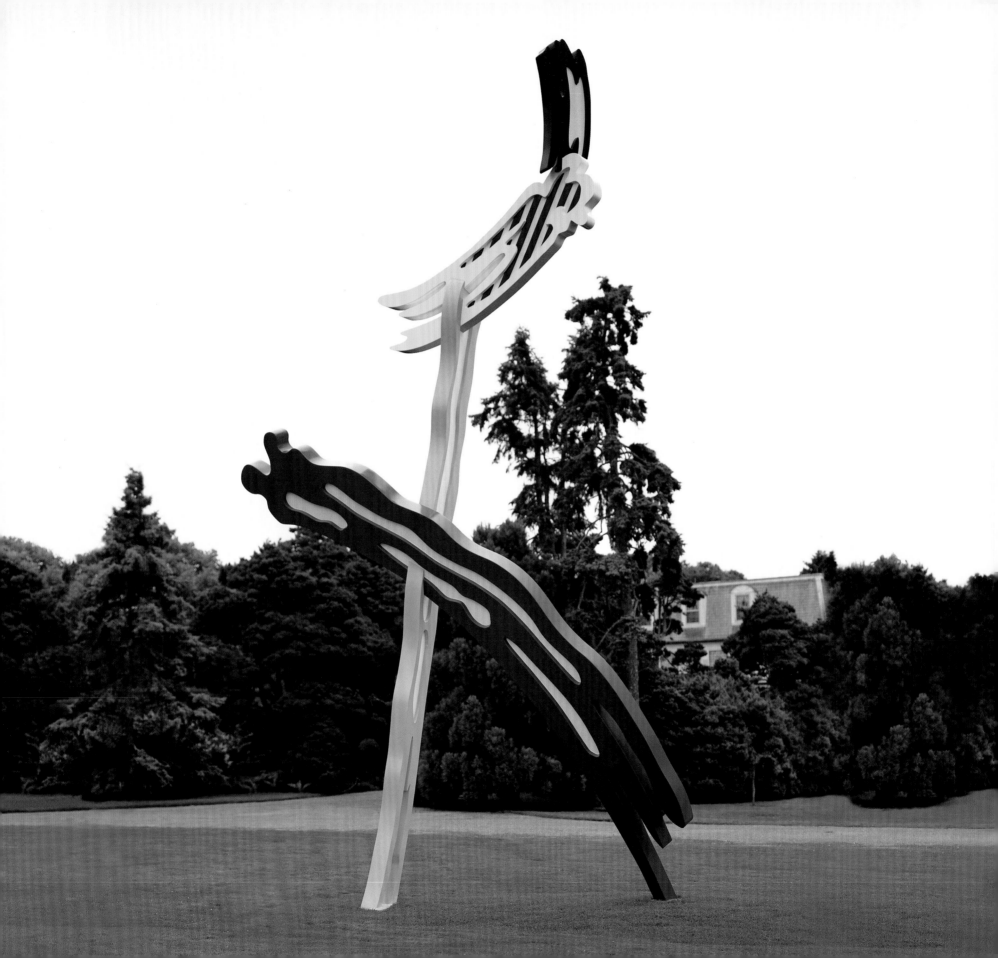

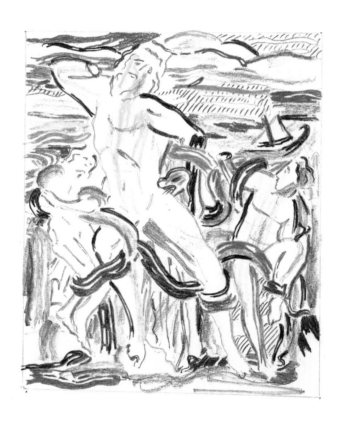

37

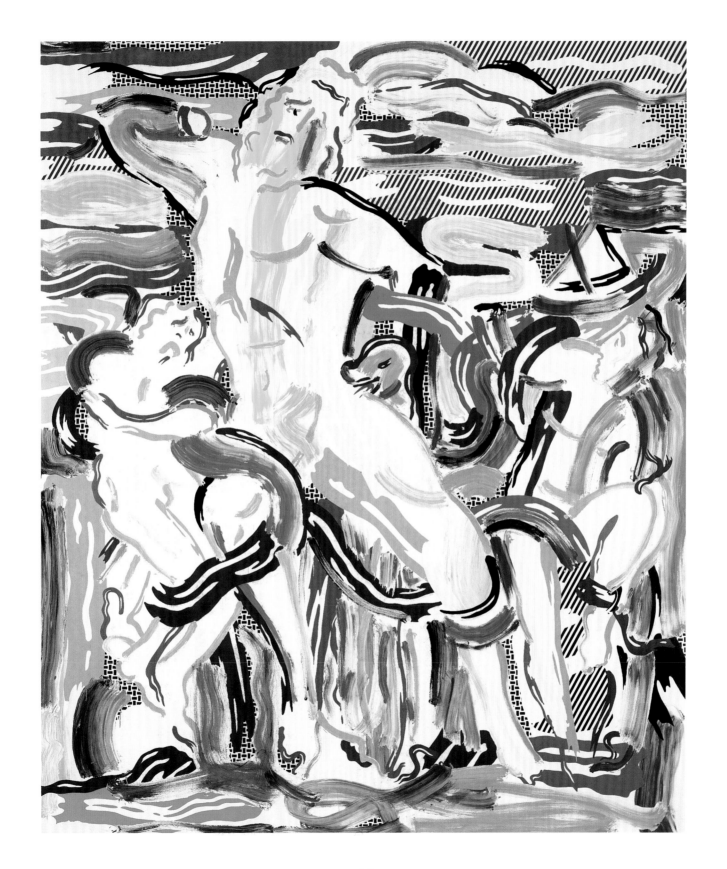

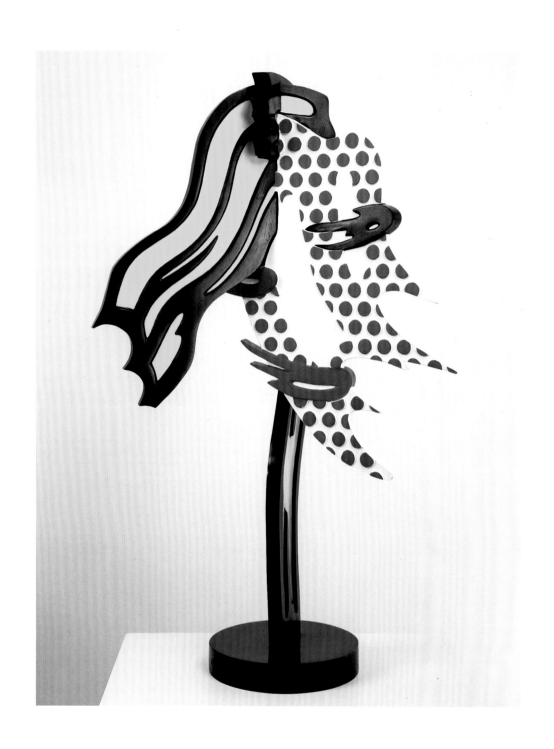

39

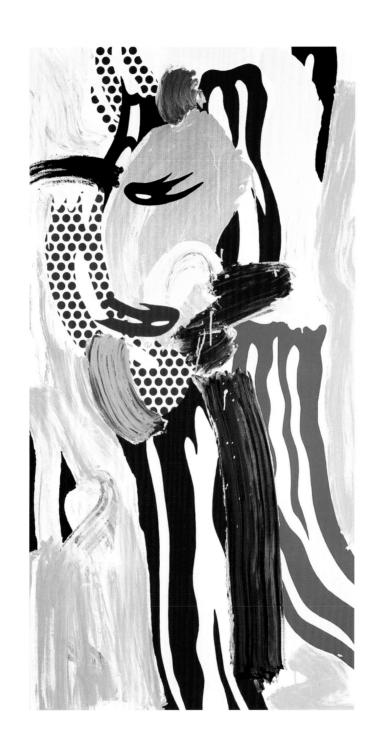

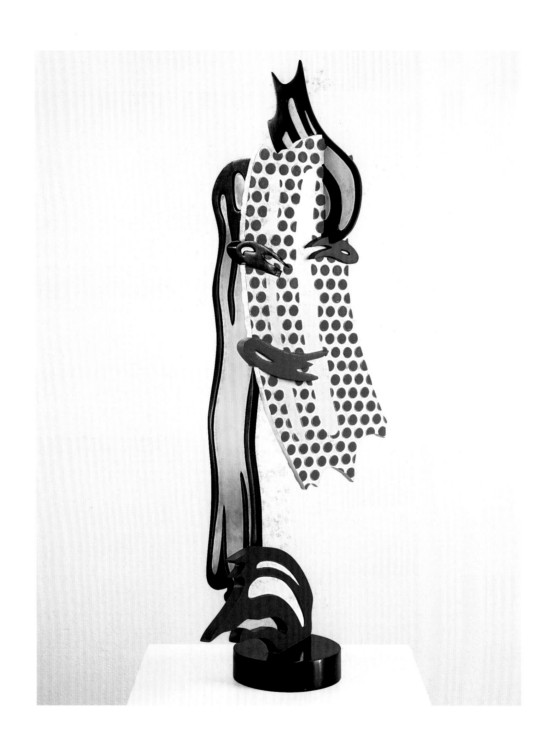

41

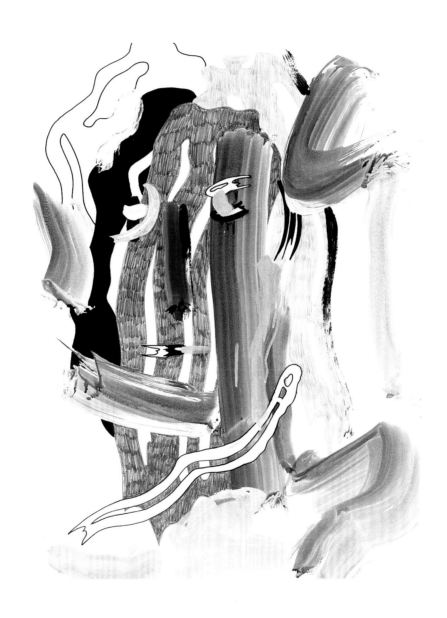

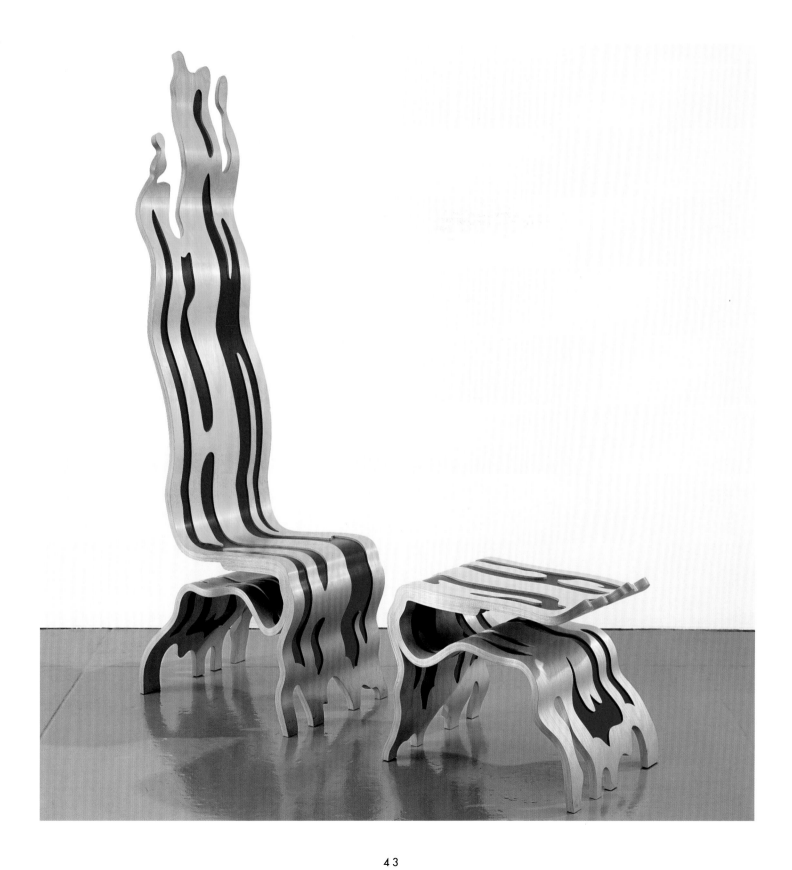

43

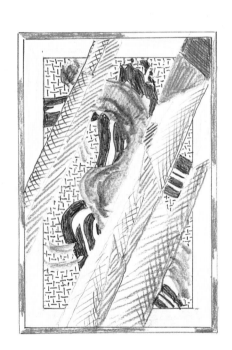

44

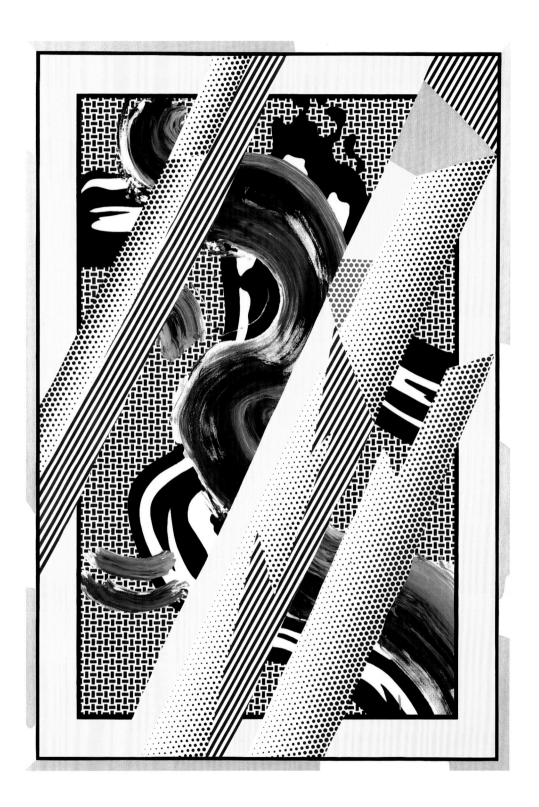

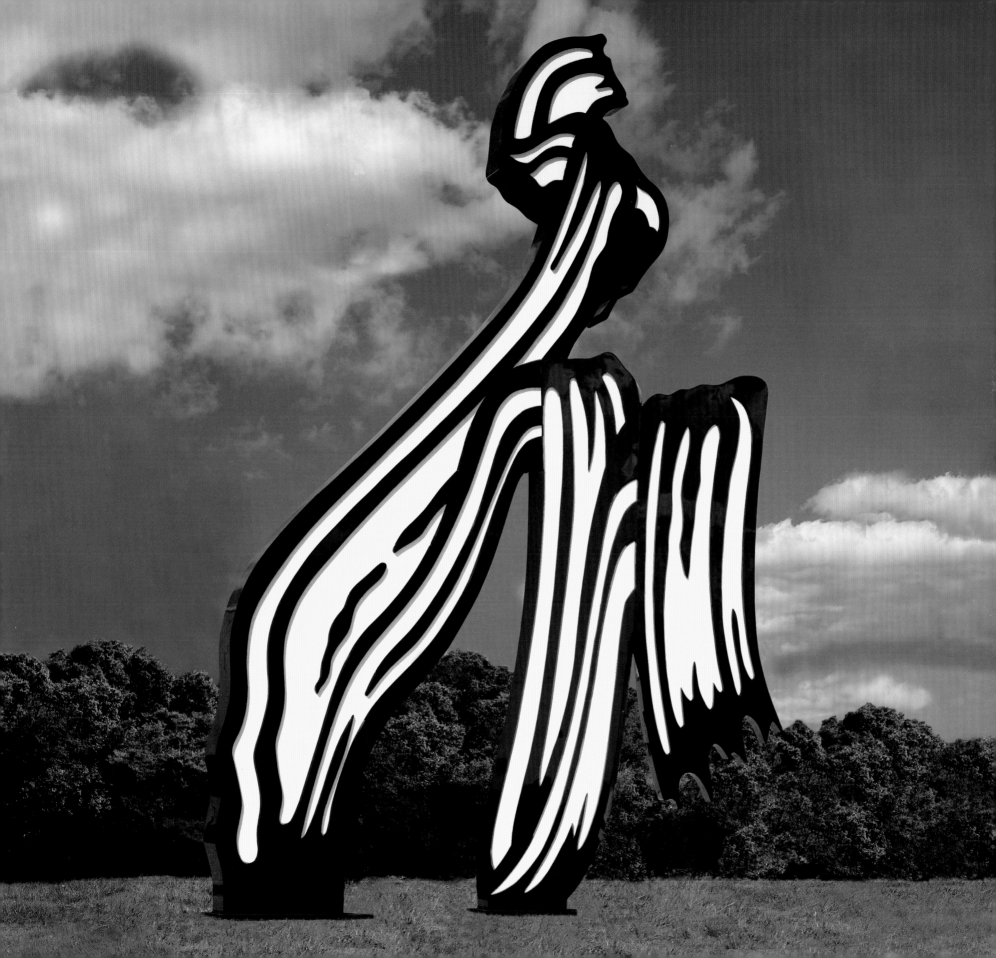

47

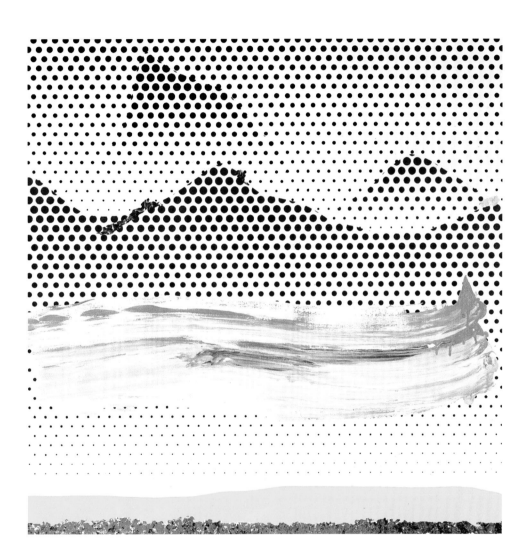

49

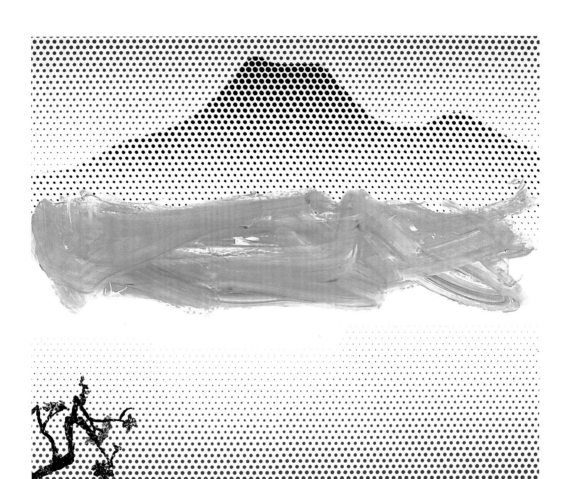

50

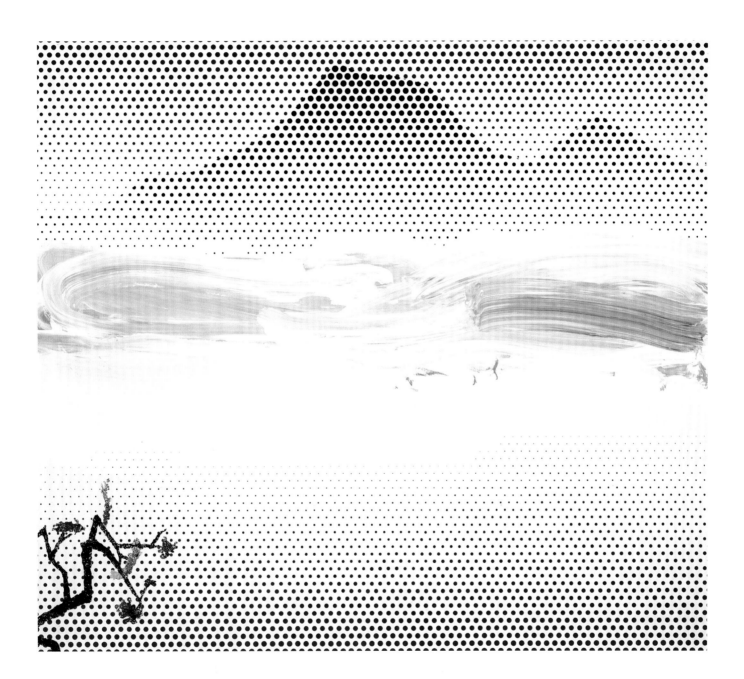

51

Roy Lichtenstein: a Select Biography

"I like the contrast between the real and the cartoon brushstrokes, but the works still are calculated in the sense that each brushstroke is a single one that goes on in a particular way. Let's just say that the new pieces are spontaneous only in relation to me."
Roy Lichtenstein

1923 Roy Fox Lichtenstein is born October 27 in Manhattan. Early in his childhood, he develops a strong interest in drawing and science and spends time designing model airplanes. He listens to radio shows including "Flash Gordon" and "Mandrake the Magician."

1940 At the age of 16, Lichtenstein attends painting classes taught by Reginald Marsh (who is frequently absent) at the Art Students League, New York before beginning his undergraduate studies in Fine Arts at Ohio State University in the fall. While at Ohio State, Lichtenstein makes paintings informed by works of Pablo Picasso and Georges Braque.

1943 Lichtenstein begins a three year tour of duty in the US Army, and, after training, participates in the Allied European campaign. During his service, he draws landscapes and portraits of soldiers and other people in his sketchbooks.

1946 Following the death of his father, his discharge from the Army and the completion of his BFA at Ohio State, Lichtenstein enters the Ohio State graduate program and joins the Fine Arts department as an instructor. He receives his MFA in 1949.

During this time, Lichtenstein occasionally travels to New York and begins to visit galleries, especially Charles Egan Gallery and Betty Parsons Gallery who are exhibiting the work of Philip Guston, Franz Kline, Willem de Kooning, Barnett Newman and Jackson Pollock. Lichtenstein's work at the time is based on American genre and history painting, with recognizable subject matter, but the style is Cubist with Expressionist overtones. The subjects include musicians and landscapes, fairy tales, references to "Beauty and the Beast" and Lewis Carroll's "Alice's Adventures in Wonderland."

1951 For the next five years, while in Ohio, Lichtenstein holds various day jobs (most involving draftsmanship or small industrial design projects) and continues to bring paintings around to galleries in New York, such as Knoedler & Company and Sidney Janis Gallery. Lichtenstein is granted his first solo exhibition in Manhattan, at Carlebach Galleries. The show includes a number of medieval and fantasy

paintings and several assemblage sculptures. Later this year, initiating what will become a nine year association, John Heller Gallery presents a solo exhibition in New York of Lichtenstein's work, consisting of 16 paintings based on American historical and frontier themes, treaty signings, cowboys, Native-American Indians and several possible self-portraits as a knight.

1952 His works are shown regionally and nationally in various juried exhibitions including shows at the Denver Art Museum, the University of Nebraska, the Pennsylvania Academy of the Fine Arts and the Metropolitan Museum of Art.

The work begins to incorporate titles and advertising copy in some paintings and woodcuts. He makes assemblages of painted wood and paintings with folklore themes.

1954 Lichtenstein's son, David, is born October 9.

1956 Lichtenstein's son, Mitchell, is born March 10.

It is in this year that Lichtenstein creates his first proto-Pop work, a lithograph, entitled "Ten Dollar Bill."

1957 Lichtenstein moves to Oswego, NY and joins the art faculty at SUNY Oswego. He begins appropriating an Abstract Expressionist style in his paintings. Several cartoon characters (Mickey Mouse, Donald Duck, and Bugs Bunny) are incorporated into his brushy, expressive drawings.

1959 A series of his untitled abstractions are shown for the first time, in a solo exhibition at Condon Riley Gallery, New York.

Most of the paintings feature brilliant color on white backgrounds and contain heavy impasto. They function as a direct result of his earlier experiments in Cubist-style fracturing of space, mixed with his exposure to Abstract Expressionism. However, they are far more mannered and deliberate than the action paintings they superficially resemble. Using rags and torn bed sheets, Lichtenstein applies oil in wide, considered strokes, often multi-colored. This new direction foretells his later work of 1965 in which enlarged, stylized brushstrokes become the subject of the paintings themselves.

1960 Lichtenstein moves to Highland Park, NJ and joins the art faculty at Douglass College at Rutgers University.

He brings several of his abstractions to Leo Castelli Gallery and shows them to Castelli and his wife at the time, Ileana Sonnabend.

1961 Lichtenstein moves to lower Manhattan. Lichtenstein paints "Look Mickey." It is his first painting in which he directly appropriates a cartoon and is his first use of a dialogue balloon. He is taken on by Castelli who introduces him to Andy Warhol, Robert Rauschenberg and Jasper Johns. His first show at the gallery is the following year.

1962 Lichtenstein begins to use an acrylic paint soluble in turpentine, called Magna, but continues to use oil paint for his simulated Benday dots.

1963 Lichtenstein moves his residence and studio to lower Manhattan. In the summer of that year, he is granted his first solo exhibition in Europe, at Sonnabend Gallery, Paris.

That fall, he begins to use a Postoscope/opaque projector to render general images from the sketch to the canvas, a practice he would use throughout his career. Although the projector technique necessitates Lichtenstein to re-draft the sketch onto the canvas, obvious pencil marks disappear from his finished compositions.

1964 Lichtenstein begins to produce landscape paintings, signaling a significant move towards inventing his own subject matter and working in series. The landscapes reiterate Lichtenstein's earlier comic book style of artifice (Benday dots, black outlines, compression of space, simplified schematic forms and graphic color which he uses as signifiers of everything from hair to sky) and applies them to the subject of the natural world. Of note here is the reduction and abstraction of the subject, such as sunsets and seascapes, his most abstract work since his early paintings of the 1950s. He returns to landscape motifs twenty years later.

Inspired by New York's enameled metal subway signs, creates his first enameled steel sculptures which depict landscape scenes, heads, common objects and brushstrokes.

1965 Lichtenstein creates his first Pop "Brushstroke" painting. Later this year, Leo Castelli Gallery exhibits the "Brushstroke" series. The paintings are directly linked to, and seen as a commentary on, the Abstract Expressionist style of the 1950s (de Kooning in particular) although an immediate source for the works is a comic strip (in this case, a 1964 panel from "Strange Suspense Stories"). The first of the series retains the figurative element of an artist's hand holding a paint brush. All other works in the series more clearly isolate one or more amplified strokes, stripping the image of direct narrative, and speak to Lichtenstein's career-long exploration into the concepts and components of painting itself, namely the brushmark.

1966 Creates several paintings featuring drips and blots of paint against a graph-paper grid background.

1961: Advertising images of consumer products, black-and-white (or blue-and-white) single-object paintings. 1962: close-up paintings of women's heads, paintings based on Paul Cezanne, Piet Mondrian and Pablo Picasso, isolated words on canvas, war comics paintings. 1963: "Girls' Romances" and "Secret Hearts" paintings. 1964: Frightened and crying women series, classical subjects, Benday dots enlarge and text begins to disappear. 1965 "Explosion" sculptures, motorized collages. 1966: words disappear from compositions. 1968: "Stretcher Frame" paintings, repeated design imagery paintings. 1969 "Rouen Cathedral" series, "Mirror" and "Pyramid" series.

1971: "Entablature" series. 1972: "Still Life" series, increasing use of diagonal stripes in place of Benday dots. 1973: "Artist's Studio" series, "Constructivism" works. 1974: "Italian Futurism" paintings. 1975: "Purist" series. 1976: "Office Still Lifes" series. 1977: "Surrealist" series. 1979: "German Expressionist" series.

1982: "Paintings" and "Two Paintings" series. 1984: begins "Mural with Blue Brushstroke" for the Equitable Tower, New York. 1986: "Perfect" and "Imperfect" paintings. 1988: "Reflections" series, "Plus and Minus" paintings. 1989: the "Bauhaus Stairway" mural for I. M. Pei's Creative Artists Agency building in Los Angeles.

1967 The Pasadena Art Museum (now the Norton Simon Museum), presents the first traveling retrospective of Lichtenstein's work. That year, the Stedelijk Museum, Amsterdam presents the artist's first retrospective in Europe. Two years later, the Solomon R. Guggenheim Museum, New York presents the first New York retrospective of Lichtenstein's paintings and sculptures.

1970 Lichtenstein finds a house in Southampton, NY, where he sets up his studio and a permanent residence the following year. He will return to a Manhattan studio, at least part-time, in 1984. His "Modern Head" a 30-foot-high sculpture in wood and polyurethane (based on the small-scale 1970 sculpture of the same name) is assembled on a site in the Santa Anita Fashion Park in Arcadia, CA. It is his first public sculpture.

1975 Lichtenstein begins to make painted and patinated sculptures in bronze depicting cups and saucers, drinking glasses, tea pots, mirrors and lamps.

1981 Lichtenstein revisits the theme of the brushstroke with his four "Woman" paintings evoking de Kooning's "Woman" series from the early-1950s. He uses cartoon-style Abstract Expressionist brushstrokes to create the compositions. The brushstrokes are developed from small painted drawings which are often executed on acetate (Lichtenstein was interested in the physics of the pigment drying on a non-porous surface). This study, projected onto canvas, is then replicated free-hand by the artist in graphite and the brushstrokes are individually painted in. Occasionally, template cut-outs of brushstrokes will be taped in place while Lichtenstein determines the final palette.

Like his "Brushstroke" series from 1965, these works are a complex comment on the huge shadow cast on the art world by Abstract Expressionism. Lichtenstein is also self-reflexive in these works which link back to his late-1950s paintings as well as the 1965 series. However, unlike the isolated brushstrokes of the 1960s, the brushstrokes here are formally united in order to give shape to a figurative subject although in the process they are frequently transformed beyond recognition from the original acetate drawings.

1982 Lichtenstein begins to combine loosely painted brushstrokes (which he has called "spontaneous") with constructed (or "cartoon") brushstrokes in his paintings. The complexity of these paintings is achieved in numerous ways, many of which signal a return to earlier, pre-Pop techniques. After the initial drawing is projected and traced onto the canvas, Lichtenstein begins applying the brushstrokes. For the more painterly brushstrokes, the artist applies oil to rags or brushes, and, with great control, replicates a broad "gesture." The more constructed/cartoon brushstrokes are then painted in around these carefully taped off areas to retain sharp edges and their flatness. When one brushstroke intersects another already laid

down, Lichtenstein often removes the passage completely so that there is no overlap. The melding of these two techniques allows Lichtenstein to tackle old subjects with a new vision. Subjects include a "Landscape" series with sunset subjects and pastoral themes, some with figures, such as "The Old Tree" (1984) and a "Classical" series (including a 1988 rendering of the 1st Century AD marble the "Laocoon Group").

1987 The Museum of Modern Art, New York mounts the first major retrospective exhibition of Lichtenstein's drawings.

The 1980s see his monumental sculpture gaining a wider audience. In 1983 Lichtenstein's "Brushstrokes in Flight" debuts at the entrance of the International Airport in Columbus, Ohio. "Salute to Painting" (1986) a large outdoor sculpture is installed at the Walker Art Center in Minneapolis. His "Coup de Pinceau (Brushstroke)," a 31-foot-high aluminum sculpture, is installed at the Caisse de Depots et Consignations, Paris in 1988. And in 1989, "Brushstroke Group," a 30-foot-high painted aluminum sculpture created in 1987, is installed at the Doris C. Freedman Plaza, Manhattan.

1992 Lichtenstein creates "Barcelona Head," a 64-foot-high sculpture made of colored ceramic tiles, commissioned for the Summer Olympics and installed in Barcelona, Spain.

1993 Lichtenstein completes "Brushstroke Nude," a 12-foot-high painted aluminum sculpture which debuts on the sidewalk in front of the Guggenheim for the retrospective, "Roy Lichtenstein." He also embarks on a series of sculptures based on brushstrokes and drips including the multi-pieced outdoor works "Tokyo Brushstroke I" and "Tokyo Brushstroke II" (1993-4) installed in Nishi-shinjuku, Japan and "Endless Drip" (1995), a wry comment on Constantin Brancusi's "Endless Column."

1990: "Interior" series which use sponges instead of rags in order to convey foliage. 1994: a series depicting female nudes.

1995 Lichtenstein is inspired by the exhibition of Edgar Degas monotypes and pastel landscapes at the Metropolitan Museum of Art, New York, which awakens his long-held interest in Asian art. He begins a large series of works "Landscapes in the Chinese Style" later shown in 1996 at Castelli.

1996 Lichtenstein conceives several monumental sculptures including the "House" group I - IV, "Brushstrokes," the large yellow "Brushstroke" and "Pyramid."

1997 "Singapore Brushstroke," the artist's major outdoor sculpture comprised of 6 large pieces is installed at the Pontiac Marine Plaza, Singapore.

1997 Roy Lichtenstein dies September 29 in New York.

Plates

1 *Variations #7*, 1959, Oil on canvas
 48 x 60 in. (121.9 x 152.4 cm.)

2 **Untitled**, Circa 1959, Gouache and pastel on paper
 19 x 24⁷/8 in. (48.3 x 63.2 cm.)

3 **Untitled**, Circa 1959, Gouache and pastel on paper
 19 x 24¹⁵/₁₆ in. (48.3 x 63.3 cm.)

4 **Untitled**, Circa 1959, Oil on canvas
 68³/4 x 47³/4 in. (174.6 x 121.3 cm.)

5 **Brushstroke studies**, 1965-66, Ink on paper
 26⁷/8 x 20¹/8 in. (68.3 x 51.1 cm.)

6 *Yellow Brushstroke II*, 1965, Oil and magna on canvas
 36 x 108 in. (91.4 x 274.3 cm.)

7 **Final study for** *Landscape with Figures*, 1977, Graphite and
 colored pencils on paper, 13¹/2 x 21 in. (34.3 x 53.4 cm.)

8 **Magna study for** *Woman III*, Circa 1982, Magna on acetate
 over graphite on paper, 5¹/4 x 3³/4 in. (13.3 x 9.5 cm.)

9 *Woman III*, 1982, Oil and magna on canvas
 80 x 56 in. (203.2 x 142.3 cm.)

10 **Magna study for** *Two Apples*, 1981, Magna on acetate on paper
 7 x 10¹/4 in. (17.8 x 26 cm.)

11 *Two Apples*, 1981, Magna on canvas
 24 x 24 in. (61 x 61 cm.)

12 **Magna study for** *Sailboats*, 1981, Magna on acetate on paper
 7 x 10³/8 in. (17.8 x 26.4 cm.)

13 *Sailboats*, 1981, Magna on canvas
 40 x 60 in. (101.6 x 152.4 cm.)

14 **Magna study for** *Flowers*, 1981, Magna on acetate over
 graphite on paper, 10¹/8 x 7 in. (25.7 x 17.8 cm.)

15 *Flowers*, 1981, Magna on canvas
 48 x 36 in. (121.9 x 91.4 cm.)

16 **Drawing for** *Brushstrokes In Flight*, 1981, Graphite and colored
 pencils on paper, 7 x 4⁵/8 in. (17.8 x 11.7 cm.)

17 *Brushstrokes In Flight*, 1983
 Painted and patinated bronze, Edition of 6
 57³/4 x 2¹/4 x 9³/8 in. (146.7 x 5.7 x 23.8 cm.)

18 **Drawing for** *Landscape Through the Trees*, 1984, Graphite on
 paper, 10¹/4 x 7¹/2 in. (26 x 19.1 cm.)

19 *Landscape Through the Trees*, 1984, Magna on canvas
 36 x 24 in. (91.4 x 61 cm.)

20 *Composition*, 1982, Magna on canvas
 28 x 24 in. (71.1 x 61 cm.)

21 **Brushstroke Landscape study**, 1986, Watercolor and graphite
 on paper, 7¹/2 x 6 in. (19.1 x 15.2 cm.)

22 **Drawing for** *The Old Tree*, 1984, Graphite and colored pencils
 on paper, 10³/8 x 7⁷/₁₆ in. (26.4 x 18.9 cm.)

23 *The Old Tree*, 1984, Oil and magna on canvas
 72 x 60 in. (182.9 x 152.4 cm.)

24 **Drawing for** *Drowning Muse*, 1986, Graphite and colored
 pencils on paper, 9 x 5 in. (22.9 x 12.7 cm.)

25 *Drowning Muse*, 1986, Oil and magna on canvas
 42 x 50 in. (106.7 x 127 cm.)

26 **Reclining Nude in Brushstroke Landscape study**, 1986
Watercolor and graphite on paper, 6 x 9 in. (15.2 x 22.9 cm.)

27 **Reclining Nude in Brushstroke Landscape study**, 1986
Watercolor and graphite on paper
10⁷/8 x 14 in. (27.6 x 35.6 cm.)

28 **Drawing for *Figures in Landscape***, 1985, Graphite and colored
pencils on paper, 7⁷/8 x 10³/8 in. (20 x 26.4 cm.)

29 *Figures in Landscape*, 1985, Oil and magna on canvas
96 x 110 in. (243.8 x 279.4 cm.)

30 **Drawing for *Sunrise***, 1984, Graphite and colored pencils on
paper, 3 x 4³/16 in. (7.6 x 10.6 cm.)

31 *Sunrise*, 1984, Oil and magna on canvas
36 x 50 in. (91.4 x 127 cm.)

32 **Drawing for *Painting: Bamboo Frame***, 1984, Graphite and
colored pencils on paper, 7³/8 x 6 in. (18.7 x 15.2 cm.)

33 *Painting: Bamboo Frame*, 1984, Oil and magna on canvas
36 x 40 in. (91.4 x 101.6 cm.)

34 **Drawings for *Paintings: Picasso Head***, 1983, Graphite and
colored pencils on paper, 13¹/8 x 9³/16 in. (33.3 x 23.3 cm.)

35 *Paintings: Picasso Head*, 1984, Oil and magna on canvas
64 x 70 in. (162.6 x 177.8 cm.)

36 *Brushstrokes*, 1996
Painted aluminum, Edition of 1, 1 AP
29¹/2 x 13¹/2 x 7¹/2 ft. (9 x 4 x 2.2 m.)

37 **Drawing for *Laocoon***, 1988, Graphite and colored pencils on
paper, 11 x 11 in. (27.9 x 27.9 cm.)

38 *Laocoon*, 1988, Oil and magna on canvas
120 x 102 in. (304.8 x 259.1 cm.)

39 *Brushstroke Head II*, 1987
Painted and patinated bronze, Edition of 6, 1 AP
28⁷/8 x 13¹/4 x 17¹/4 in. (73.3 x 33.7 x 43.8 cm.)

40 *Fashionable Lady*, 1986, Oil and magna on canvas
60 x 31 in. (152.4 x 78.7 cm.)

41 *Brushstroke Head I*, 1987
Painted and patinated bronze, Edition of 6, 1 AP
39³/4 x 16¹/2 x 8¹/2 in. (101 x 41.9 x 21.6 cm.)

42 *Brushstroke Face*, 1987, Graphite, ink and magna on paper
30 x 20¹/4 in. (76.2 x 51.4 cm.)

43 *Brushstroke Chair* and *Brushstroke Ottoman*, 1986-1988
Painted wood, Edition of 12
Chair: 70¹¹/16 x 18 x 27¹/4 in. (179.5 x 45.7 x 69.2 cm.)
Ottoman: 20³/4 x 17³/4 x 24 in. (52.7 x 54 x 23.8 cm.)

44 **Drawing for *Reflections on Brushstrokes***, 1989, Graphite and
colored pencils on paper, 11 x 7¹/2 in. (27.9 x 19.1 cm.)

45 *Reflections on Brushstrokes*, 1990, Oil and magna on canvas
87 x 60 in. (221 x 152.4 cm.)

46 *Brushstroke*, 1996
Painted aluminum, Edition of 1, 1 AP
32 ft. 3 in. x 21 ft. x 6 ft. (9.8 x 6.4 x 1.8 m.)

47 **Drawings for *Brushstroke Still Life* and *Small Landscape***, 1996
Graphite and colored pencils on paper
8 x 8¹/2 in. (20.3 x 21.6 cm.)

48 *Small Landscape*, 1996, Oil and magna on canvas
30 x 30 in. (76.2 x 76.2 cm.)

49 **Drawings for *House III* and *Landscape in Fog***, 1997
Graphite and colored pencils on paper
10 x 13 in. (25.4 x 33 cm.)

50 **Collage for *Landscape in Fog***, 1996, Tape, painted and printed
paper on board, 39⁷/8 x 44³/4 in. (101.3 x 113.7 cm.)

51 *Landscape in Fog*, 1996, Oil and magna on canvas
71 x 81³/4 in. (180.3 x 207.6 cm.)

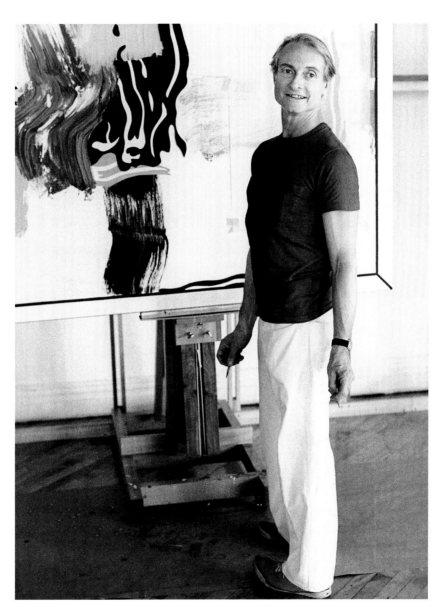

Roy Lichtenstein with **Painting: Silver Frame** in his 29th Street studio, 1984

This catalogue was published on the occasion of the exhibition
Roy Lichtenstein Brushstrokes: Four Decades
held at Mitchell-Innes & Nash, New York
November 1, 2001 – January 12, 2002

Publication © 2001 Mitchell-Innes & Nash
Essay © 2001 Dave Hickey

All works © Estate of Roy Lichtenstein

Design: Dan Miller Design, New York
Printing: Finlay Printing, Bloomfield, Connecticut

ISBN: 0-9713844-1-X

MITCHELL-INNES & NASH
1018 Madison Avenue New York NY 10021 USA
Tel 212-744-7400 Fax 212-744-7401
Email info@miandn.com
Web www.miandn.com

Available through D.A.P./Distributed Art Publishers
155 Sixth Avenue 2nd Floor New York NY 10013
Tel 212-627-1999 Fax 212-627-9484

Plate Photography: Noel Allum Photography; Tom Powell Imaging, Inc.;
Robert McKeever; Kevin Ryan

Front Cover:
Detail of *Figures in Landscape*, 1985
Oil and magna on canvas
96 x 110 in. (243.8 x 279.4 cm.)

Endleaf, Opposite Inside Front Cover:
Brushstroke studies (Sketchbook F, page 37), 1980
Graphite and colored pencils on paper
8 3/4 x 5 7/8 in. (22.2 x 14.9 cm.)

Endleaf, Opposite Page 1:
Detail of *Drowning Muse*, 1986
Oil and magna on canvas
42 x 50 in. (106.7 x 127 cm.)

Page 2:
Roy Lichtenstein in his 29th Street studio, 1986
© Gianfranco Gorgoni

Fig. 3:
Photographer Unknown
Courtesy Estate of Roy Lichtenstein

Figs. 4 and 5:
Photograph © Michael Abramson

Page 87:
Photograph © Robert McKeever

Endleaf, Opposite Page 88:
Detail of *Drowning Muse*, 1986
Oil and magna on canvas
42 x 50 in. (106.7 x 127 cm.)

Endleaf, Opposite Inside Back Cover:
Brushstroke studies (Sketchbook F, page 33), 1980
Graphite and colored pencils on paper
8 3/4 x 5 7/8 in. (22.2 x 14.9 cm.)

Back Cover:
Drawing for *Figures in Landscape*, 1985
Graphite and colored pencils on paper
7 7/8 x 10 3/8 in. (40.3 x 26.4 cm.)

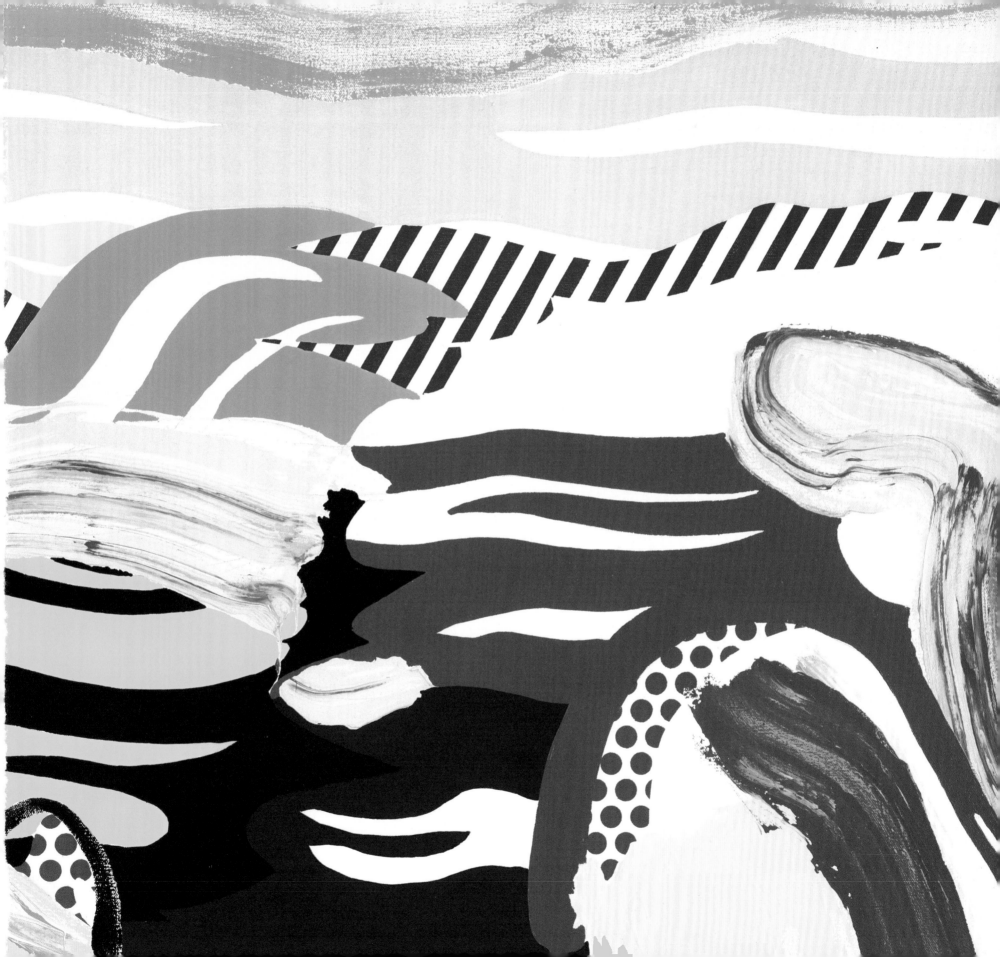

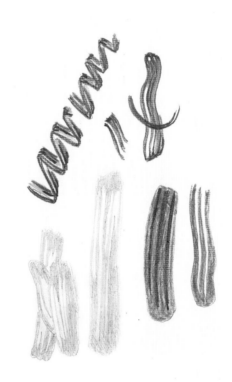